Beyond Words

A Guide to DRAWING Out Ideas

MILLY R. SONNEMAN

Ten Speed Press
Berkeley, California

Ten Speed Press
P.O. Box 7123
Berkeley, California 94707

Distributed in Australia by E. J. Dwyer Pty. Ltd., in Canada by Publishers Group West, in New Zealand by Tandem Press, in South Africa by Real Books, in Singapore and Malaysia by Berkeley Books, and in the United Kingdom and Europe by Airlift Books.

Text and cover design by Victor Ichioka

Library of Congress Cataloging-in-Publication Data
on file with the publisher

First printing, 1997

Printed in the United States of America
1 2 3 4 5 6 7 8 9 10 — 01 00 99 98 97

*For my mom, whose love supports me to give voice
to my inner and outer experiences.*

*For my dad, igniting my courage to receive,
embrace and bring ideas into form.*

Your Rose is blooming in the garden of love.

v

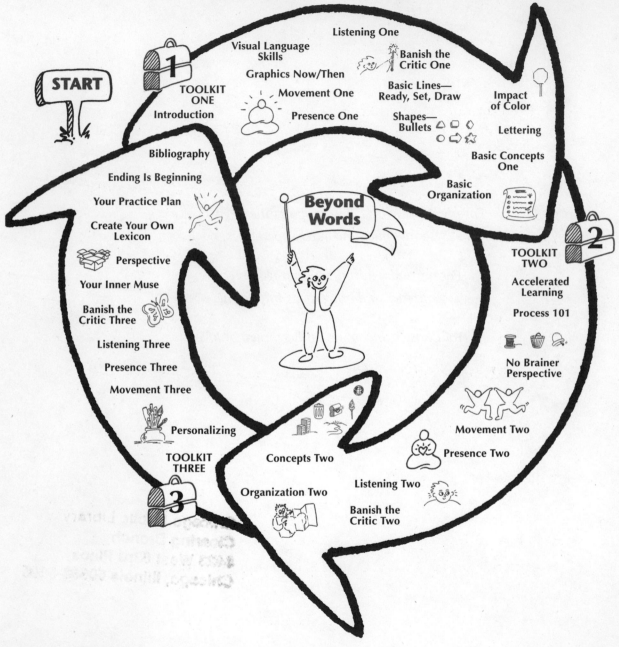

START

1 TOOLKIT ONE
Introduction

Visual Language Skills

Graphics Now/Then

Movement One

Presence One

Listening One

Banish the Critic One

Basic Lines—
Ready, Set, Draw

Shapes—
Bullets

Impact of Color

Lettering

Basic Concepts One

Basic Organization

2 TOOLKIT TWO

Accelerated Learning

Process 101

No Brainer Perspective

Movement Two

Presence Two

Listening Two

Banish the Critic Two

Concepts Two

Organization Two

3 TOOLKIT THREE

Personalizing

Movement Three

Presence Three

Listening Three

Banish the Critic Three

Your Inner Muse

Perspective

Create Your Own Lexicon

Your Practice Plan

Ending Is Beginning

Bibliography

Beyond Words

⋄ Contents ⋄

· Foreword ·

In 1990, a client asked if I would be willing to work with a graphic recorder as we launched a major project with a group of engineers. As visualization and creativity were essential to the project, I readily agreed—and the quality of my facilitation skills, the quality of "product" I can supply my clients, and my control of the planning process changed forever.

I learned that graphic recording and facilitation do more than just bring pictures to the same old wall charts and graphs. When I began adding graphics and color and using various formats to represent ideas, the whole way that my group reacted to the process underwent a major shift. We know that the human mind organizes and responds to information and stimuli by organizing them into complex maps of images and labels—thus the maps created in graphic facilitation speak directly to our most natural way of understanding, connecting, and analyzing a wealth of information. In addition, graphically recording a group discussion allows different people to absorb new information in the way they're most comfortable with—some respond best to the image maps, some prefer to concentrate on the words.

I have since used this sort of graphic facilitation in both large and small meetings, and have found that it works equally well in a broad range of settings. The concepts and skills can be used effectively with 220 people gathered in a huge room for a strategic planning session, or in a small, high-powered board meeting. In addition, these methods work well in concert with other technology—perhaps using computer-generated graphics to project the results from thirty small groups on a large screen for everyone to see. The principles of graphic facilitation represent a curious blend of group dynamics, learning theory, and cognitive mapping. This set of techniques can change any meeting from a contest of battling words to a collage of cooperating ideas.

Milly Sonneman exemplifies this approach in her work as a graphic facilitator. Her energy, enthusiasm, and exceptional ability in this field truly take it to a new level. In Milly's hands, it becomes clear how this new discipline can help any and all of us to preserve our words, map our concepts, and connect our thoughts with those of others. She moves any meeting beyond words. And she readily shares her love of this craft with others. Milly is truly a partner and a joy to work with on any project. As you can readily see, she brings her energy, passion, and skills to you in this book. Enjoy!

—Ronald E. Galbraith
Management 21

· Acknowledgments ·

I am deeply grateful to many people who have helped me in my exploration of a graphic language. Every time I use it, I learn something new from the students, meeting participants, and clients. Each of these experiences has helped shape my understanding and added to the texture of this book. Many people have participated in my journey, but I wanted to specifically acknowledge the following for their contributions.

My thanks go to:

- David Jenkins for getting me started and encouraging my experiments.
- David Sibbett for introducing me to graphic language and sharing his insights and clarity of thinking, and also encouraging me to draw, draw, draw!
- Julie Batz for being ever supportive, profoundly awake to the intricacies of what is actually going on in this work, and for her wise reading of the manuscript.
- Steven McHugh for many opportunities to provide graphic facilitation for meetings, organizational change initiatives.
- Ron Galbraith for teaching by example, and sharing the treasure he is in his wisdom and work.
- Goldie Curry for such loving, steady support for myself and Hands•On Graphics through all the torrents of ideas, especially while I immersed myself in bookland.
- Harman Bende for providing his insight, precision reading, and input that helped clarify ideas early on.
- Sonja Sakovich for constant support, reading, writing, and encouragement.

- Jane McKean for good mischief and elfin rescue in the final hours.

To the contributors of quotes: Richard Gosselin, Candace Thompson, Nancy Jokovich, Frank Patalano, Joel Orgill, Judi Daley, and Andy Owen Jones, who reaffirmed the usefulness of this information.

To all the participants of the Hands•On Graphics trainings who take this work and run with it.

To the folks at Ten Speed Press:

- George Young, who recognized that there was a book waiting to be written.
- Kirsty Melville for making contracting the most fun business interaction I've ever had.
- Mariah Bear for clear-headed editing and guidance through the process.
- Victor Ichioka for making my ideas and images come to life on the page.
- Barbara King for precision editing.

• Introduction •

*Participants in our classrooms and meetings
never fail to comment about our use of color and
images that help make concepts come alive for them.*

—Candace Thompson, First Chicago NBD

I started doing this work with the firm conviction that I couldn't draw. In 1989, I had no idea that graphic facilitation existed as a field. I took a two-day course called "Fundamentals of a Graphic Language" and a whole new world opened up to me.

Unleashed, I plastered all walls with paper. At the time I was working with David Jenkins on starting a mediation company. David had sent me to the graphics course and welcomed the drawings I did. I mapped out options during mediations. At the office, I created charts for business strategies and marketing plans. At home, I captured phone conversations, discussions, and created road maps to help friends through transitions.

In David Sibbet's graphic language course, I learned that simple drawings worked the best, and that a drawing only needed 30 percent of reality to be recognizable. Even my squiggles were 30 percent real; I could do that! I also learned that graphic facilitation was more than just drawing. My background in movement, improvisation, working with imagery, and mediation directly applied to graphic facilitation—experiences that shaped and fueled my work. I felt encouraged to apply the skills at every opportunity, both personally and professionally.

Shortly afterward, I found myself needing to create my own transition map. Sitting in the center of conflict, in rooms filled with angry lawyers, was

very intense and disturbing. I wanted to shift my work to help resolve conflict and facilitate communication. I took time off to reflect and work my way through *What Color is Your Parachute?* I scribbled and drew ideas on pads of newsprint, covering every wall of my house, mapping out all my options.

One day, coming in from a walk, I looked around and saw the obvious. The answer was not in the content, it was in my process. I enjoyed doing this drawing thing! Sitting on the floor, staring at mounds of drawings, I knew I'd come home. I still didn't think I could *really* draw—but that was the beginning of Hands•On Graphics.

Now, many drawings, meetings, and trainings later, I want to share the power and benefits of this work with you. Over the last eight years, I have found myself in situations I could not have imagined. I've mapped out strategies at rosewood boardroom tables, drawn out underlying emotions behind executive closed doors, worked in retreats of 100 to 200 people, anchoring their vision. It has been and continues to be immensely rewarding to provide graphic facilitation for groups and teams.

Training others in the use of a graphic language evolved from people asking me what the heck I was doing. I have worked with facilitators, trainers, and managers in corporations all over the United States and Europe, adapting the graphic language to their content and context.

This guide's long-term goal is to help you promote interaction, encourage collaborative problem solving, lead groups through the quagmire of complex issues, diverse opinions, and conflicting interests. You will learn to make concepts stand out in people's minds—whether in facilitation, presentations, training, or sales. The graphics tools in this book are the means for you and your clients to achieve these impact-full goals.

If you are a facilitator, you will find that a graphic representation of pictures, combined with words, helps people stay focused and on track. As participants watch a chart being creating from their words, they are prompted to

say more, interact with the charts and each other, make connections between apparent paradoxes, and synthesize ideas.

If you are a trainer, educator, or presenter, discover how to make concepts visually memorable. By drawing graphics live or in advance, you anchor information with color, pictures, repeating shapes, and formats. The visual support of handouts, course material, posters, and live discussion, forms a thread tying concepts together in the viewers' minds.

For example, if you're in sales (and these days who isn't) and you have an interactive sales meeting, mapping out customer concerns and issues will literally show that you are listening! When you leave a chart or sketch behind, the clients have something memorable in their office—on their walls or desks. They'll call others in to look at it and discuss it. You achieve several goals: the process was interactive, they told you their concerns, you listened, they keep talking about the interaction and your ideas, services, or products. You have seeded the discussions that will lead to creative solutions, and you'll be part of the continuing dialogue.

The processes that can be mapped out are not limited to but include brainstorming, strategic planning, conflict resolution and mediation, teaching, presenting ideas, project planning, business planning, career and transition planning, and counseling. If you are working with yourself, you can use this information to map out your perceptions, plans, options. In personal and professional life, any time people are gathered together to discuss options, ideas, strategies, potential conflicts, history or the future—it's a good time to get out the paper and start mapping. For the purposes of teaching and clarifying complex information, get out the markers.

I take immense pleasure in helping people abandon the belief that they can't draw. Clients I've worked with are primarily corporate trainers, facilitators, and internal consultants. I've also held public seminars for individuals from corporations, as well as independent consultants, to learn these skills.

I thought you might enjoy reading people's own words about how and where they have used graphic language and the impact of using the tools in this book.

You can inject energy through graphics.
Energy in the room drives the meeting.
Graphics added a whole new variety and helped
engage the total person in the training experience.

—Richard Gosselin, Senior Training Specialist
Oglethorpe Power Corporation

Learning to draw and use graphics in our training
programs has had positive impacts on several levels.
First, as we present concepts in simple graphics, students
appear to grasp and retain the information better.
This ties well to our use of accelerated learning techniques,
as we try to reach different learning styles. And, not to be
overlooked, we find that creating materials or facilitating
a class is now more rewarding as we use these
graphic techniques with confidence!

—Nancy Jokovich, *Solectron Texas*

Work through the book on your own, starting wherever your current interests or needs direct you. However, the concepts presented do build in complexity, so if you decide to bop around, check out earlier sections if you don't understand something.

The sections of this book are small so that you can pop in for a section, practice it, and then do something else. I encourage you to do the activities and also to take breaks in reading and in drawing. I know it is tempting to just keep reading and think that you will absorb it all. The physical integration of drawing and actually doing exercises will make this your own. Otherwise, you'll read "about" the experience rather than integrating it.

It is more obvious to focus not on internal experience but on external skills: how to draw particular icons, how to organize information. However, your inner experience shapes and informs your ability to be fluent in a visual language. Your internal skills include the more subtle skills for speaking a visual language: your movement, ability to listen, be present, and suspend self-criticism. Throughout the book, exercises will develop and deepen both skill sets.

Why bother? I can hear your concerns: "Hey, this is a lot of work!" "I can't even draw a straight line." "I haven't drawn since kindergarten." "People will make fun of me." " I'm not talented." "I can't think on the spot." "I can't imagine doing this live." "I'll slow the group down." Sounds pretty dismal. I understand the feelings because I have had them all.

I hear the same concerns from people taking my course. I smile and invite them to start anew. Usually by the end of the first day, they have astonished themselves. Here's what helps: willingness to put a pen to paper, self-encouragement, patience, and practice, practice, practice. If they can do it, so can you! All that is needed for you to begin is some time, space, and your willingness to experiment.

Toolkit One

Let's Start

· Toolkit One ·

Do you have that little voice that says: " I can't draw a straight line!" "I have no talent" or "I'm the one you can't teach to draw"? If so, you have come to the right place. This first toolkit will give you the basics for speaking a graphic language.

The focus is to develop your skill in drawing out ideas. Here are the materials to get started: watercolor markers, large rolls of paper, a blank journal, and a pencil. You'll need courage to make mistakes, compassion for your efforts, and zeal in banishing the inner critic. It will help to notice your breathing, be tuned in to listening, and develop an awareness of your movements. Be willing to embrace the "P" word—first there's starting and then there's practicing!

Work on large sheets of paper. This will help you get out of your own way and get more in touch with your movement. Most important, PLAY! Have fun! Allow time and room to experiment. Work on newsprint or even newspaper—you will have nothing to lose, no expensive paper to waste. Practice slowly and steadily on your own to build confidence.

Drawing is a way to extract essence and help people to think, process, focus, and even have fun while achieving results. I intend to be a catalyst for you. I want to ignite your own ability and uniqueness. My drawings, suggestions, and organizations of information are jumping-off places. Please jump!

When you keep an idea alive with a cartoon, draw a diagram to clarify a process, focus and motivate a team or organization with a vision map, you are creating powerful communications. You are on your way! Do you hear that message resounding in your head?

"KEEP DRAWING!"

The Big Picture:
A Visual Language Skills Map

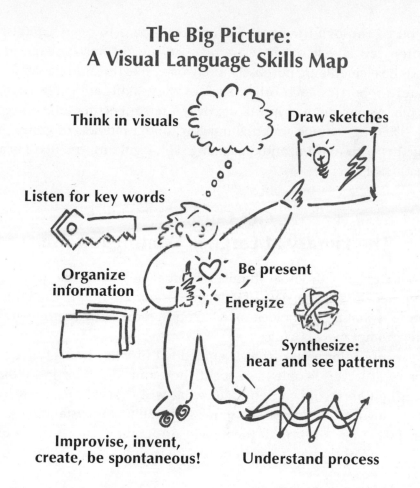

Think in visuals

Draw sketches

Listen for key words

Organize information

Be present

Energize

Synthesize: hear and see patterns

Improvise, invent, create, be spontaneous!

Understand process

Each of these topics has been written about individually, but in this book, we will look at how these skills interrelate. This is not a treatise, but an introduction and a jump-start to trigger your awareness of the skills' elements—those that you feel you have a handle on, those you don't, and those you haven't even started to consider yet.

As you go through the book, return to this page to see where else your exploration can take you. There are practice suggestions for each of these skills and the elements are purposely interwoven like threads of a fabric, interlacing and supporting each other. Each of these skills are gateways to dive deeply into. As you do so, you will discover interconnecting links where your moving, listening, sensing, internal imaging, and awareness of group process flow together with drawing and organizing skills—guiding you like a beautiful constellation of stars.

Get Curious:
The Library at Large Is Waiting for You

We are bombarded with visual stimulation on a daily basis: the mail, newspaper, computer, advertising, TV. All compete for our attention. The underlying assumption is that bigger, bolder, more colorful, more visually stimulating will sell more, prompt more buying.

We can use information that is embedded in what I affectionately call "the library at large." People have spent thousands of hours and billions of marketing dollars trying to figure out what will capture our attention. All these signs, logos, and symbols are sources of graphic understanding for us to discover. Take a new look at all the media surrounding us—review your junk mail for ideas, gather chart ideas from *USA Today*, pull ideas out from packaging that captures your eye.

The fields of architecture, advertising, accelerated learning, media, computer programs, television, multimedia, printed material, pattern design, clothing design, and product design all have information and fuel for the graphically attuned. Draw on, draw in, take note, and explore. Get curious about shapes, symbols, and logos—why something works, why you remember one image and forget the next. These are ongoing resources for you as you build your toolkit.

Get curious—this is the raw material for your present-day search.

Meanwhile, you can look back through history and glean ideas and information. Learn from both the presence of symbolic language that cuts across cultures and the value placed on symbols for wisdom and intuitive understanding, that is, the role of images within tribes and cultures. From cultural history around the world, you can gather the support of centuries for your own exploration and incorporation of graphics into whatever work you are doing.

For most indigenous cultures, the use of symbols is seen in art, clothing, baskets, pottery, and house design. The cultural associations and a general understanding of the impact of these signs has shaped the use of graphics and symbols in these cultures, as well as in our own. Common associations with basic symbols are found around the world and lead us to believe that the body has an intuitive understanding that recognizes a symbolic language.

A graphic, visual language is not something new. It is not limited to a culture, a time in history, or to any one individual. This is a time-honored way of integrating information, communicating, and sharing knowledge and insight.

EXERCISE:

Get a blank journal, a pencil, and walking shoes.

Take a walk around your neighborhood. Imagine that you have just landed from another planet. What do you notice about the signs and symbols of these people? Notice the road signs, crosswalks, markings on buildings and streets. Notice drawings on billboards, on trucks, in shop windows, and on magazines. As you walk, quickly sketch ten images that you see. Come on, no one is watching or looking at your notebook—go for it!

Take a walk through a grocery store—go shopping for images. Notice what colors attract you, what products use combinations of pictures and words. Do you see banners, flags, or ribbons on packaging? This can be an over-

whelming experience, so take care of
yourself. You may need to step
outside periodically. Be sure to
sketch some of the graphics
that catch your eye.

Take a tour through
images around your
house: Go through your
junk mail in search of
images; check out magazines, newspapers, television, and computer
screens. Add to your journal. Start a graphics file for images that you cut
out.

Use a journal without lines so you can sketch without confinement. No
one else will look at your sketches, and it's fun to capture notes of what
you see. You might get ideas later based on what you see. If you'd rather
not sketch, then skip the journal and take mental notes.

Movement, Part One

The stepchild of the twentieth century is the body.
Maligned, manipulated, either dressed or naked, the
body is often viewed as an object to improve. Yet within
your body exactly as it is now, is an immense sea of wis-
dom and inner knowing. Yes, your body, right now, already
knows how to draw. How to move. How to evoke emotion.
How to express energy. It is this basic knowing that we are
about to tap into and this will fuel your drawing.
Your arm knows how to make circles at the shoulder,
at the elbow, and at the wrist. Direct access to this body

knowledge is the key to speed, effortlessness, and energy in motion that is the foundation that will later enable you to keep up with real-time conversation speed.

EXERCISE:

Spend as long as you like flicking and shaking your arms, wrists, neck, head, legs. Imagine flicking water off like a dog does. Experiment with making huge circles, feeling the natural arc of the shoulder. Try just raising your arm and letting it drop. Experiment with slicing through the air in all directions—making a huge X, painting the air with your arm—imagine a large sword or brush and slice through the air. If you were Luke Skywalker, you would leave traces of light from your light saber...have fun playing with all the different motions. Use your knees, rotate at your waist, get your whole body into the action....

As you are doing this, remember you can always come back and reconnect with your body's energy.

Presence, Part One

The breath is a doorway to being in the present. Ongoing and an ever-present partner, it can lead us in and bring us back if our mind has hooked our attention on something else. To be present while listening, drawing, and eventually facilitating is an essential skill. It begins with being present with yourself—which is a gift to yourself and to anyone you come in contact with...

EXERCISE:

Sitting or standing, start in stillness, sensing the body. Notice the breath: is it shallow or deep? Let your hands rest on your belly and feel the breath

descending out of the chest into the belly. Increase the rise and fall of the belly so that you can really sense the difference between this and shallow chest breathing. Extend the breath, this time imagining breathing through the soles of your feet, as if your feet have roots and can pull energy and breath up through those roots. Feel the breath-energy flowing up through your feet, into your legs, filling each joint and circulating around in the pelvis. Take the breath-energy all the way up as you inhale so that it fills your chest, back, neck, head, and arms. You may find your arms naturally rising as you inhale. Then allow an exhalation as you send energy and breath out your hands. Do the same exercise in reverse: breathing energy in through the top of your head, filling the entire body, and then exhaling out through your feet.

As you get comfortable with noticing your breath, you can add some self-suggestions to help your comfort level. For example, breathing in calmness and exhaling tension is a good suggestion to start with. Breathe in clarity and exhale anything else that is competing for your attention (e.g. traffic enroute to a meeting, a laundry list of projects, or personal issues).

Next, while in a standing position, start an inner checklist to tune into how you are standing. We all have favorite places to store tension, as if the body were a treasure chest of these pockets. Tuning awareness inward is the first step to bringing relaxation to these tension points. This will strengthen your ability to be relaxed, alert, and aware of your own internal balance or center.

- Notice that your ankles can relax and allow a subtle dance of balance.
- Allow your knees to soften and bend slightly without being locked, as if there were clouds in your knees.

- Drop your pelvis, letting it hang—and feel how your lower back relaxes.

- To sense if you have extra tension in your shoulders, shrug your shoulders up and down and find a place where they are relaxed and comfortable.

- Move your jaw and let it drop open, letting go of tension stored there...

Add to this any of your own checkpoints. These form a good beginning checklist for tuning into body knowing. Right now, these checkpoints are for your awareness while drawing by yourself. As you get used to keeping some inner focus on your body sensing, you can use these points to keep you centered and calm when working with groups.

Listening, Part One

Patterns of Speech

Very few people get to the point right away. Here are some graphic examples of speech patterns you have heard, and you may even use!

Missing the point

Jumping from point to point

Driving home the point

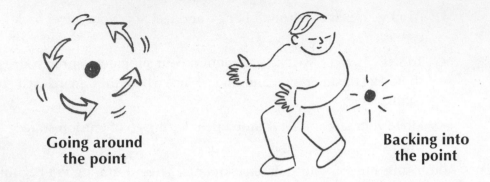

**Going around
the point**

**Backing into
the point**

Add to these cartoons your personal favorites, pet peeves, speech patterns of your parents, partner, coworker, or boss. These are rich sources for pattern listening.

Capture the Passion

The next time you are in a meeting, listen for excitement, enthusiasm, passion, and emotion. This may involve a raised or changed voice; body gestures, such as arm-waving and finger-pointing; a shift in the speaker's speech pattern. Listen with your body, sensing how your body responds by changing sensation, temperature, or feelings of expansion or contraction. Listen with your heart and belly—what do you feel and sense as people speak? What is the essence that they are expressing?

You do not have to understand the content—you can turn on the channel to pick up energy. In fact, it may be easier to do without understanding all the content. Most meetings have enough content experts in the room. When you apply this energetic listening in meetings, you are bringing something unique and needed to the session.

This is a good one to practice with TV, radio, family members, coworkers. Let your attention shift off content and onto sensing the impact of what is being said. You may perceive this as a gut reaction, what you get an image of, or what words seem to stand out, are lit up, or have more substance.

This is a little like watching the TV with the sound turned off—you are watching energetics with the words turned off for now.

This will help you listen through the words rather than to the words. Emotion, excitement, and charge direct you to hear what is important for the speaker. These are tools you can use anywhere and any time.

Use the Participants' Words: A Few of Them

There is little more alienating to participants than having their words changed somewhere in the airspace between their mouths and the wall chart. If you have ever had this happen to you, you know what's next...you fold your arms across your chest and turn into an observer. Since you don't want to have that effect on people, listen carefully to their words and use them. Use the essential ones and leave the rest. Listening for and capturing the essence of the words buys you time to draw a sketch now and then.

EXERCISE:

Bring your notebook to a meeting at work, church, a club, or community organization. As people talk, select what is essential. Sometimes as few as three words capture a paragraph of speech. Get ruthless in your selection but still use their words. No one else needs to see what you are doing, so this is a safe way to practice capturing the essence.

Listen for Visual Metaphors

"Overarching principle"…"an umbrella organization"…"Band-Aid solution"…
"it's a lemon"…"a pie in the sky." These are examples of visual metaphors that
call forth tangible images. Because 80 percent of the population are visual
thinkers, capturing these visual metaphors with a sketch will captivate your
audience.

EXERCISE:

Watch TV and listen for visual metaphors. At first, listen without doing
anything else. Next, listen and write the words…and you guessed it…write
the words and draw a graphic around the words.

Banishing the Critic, Part One: Scribbling

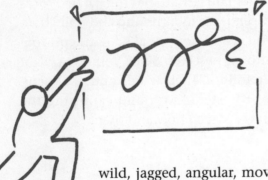

Huge sheet of paper. Crayons, mark-
ers, markers, paints. Go for it. I mean really
wild scribbles, no tracking, no time
limit. Scribble to Beethoven's Ninth
Symphony. Scribble with abandon.
Scribble with your eyes closed.
Scribble things that make no sense.
Sense your body—moving bigger, and
wild, jagged, angular, moving in circles and spirals—change your
mind and create one gigantic mess…then another and another.
You cannot fail at this. Let go again and this time scribble bigger,
faster, slower, longer…play with it. You are loosening the threads that may
reach back many years, only this time you don't have to stay within the lines
and no one is going to grade your paper.

Scribbling with a Story

This is the first of several encounters with the inner critic. Time now to reveal and rebuke the critic while scribbling.

You may remember this from when you were a child or if you have children. While scribbling, tell a story to yourself. Tell a story about anyone who ever said anything about you as an artist. Was there someone in your life who claimed to be Talented with a capital "T," so you weren't, someone who told you that people don't have purple hair or that the sun isn't really green and trees aren't pink? (You might have been tuning into the punk aesthetic, eclipses, and trees at sunset.) While scribbling, remember and also scribble out your response: It's no longer current, relevant, wasn't, isn't, and won't be true any time in this lifetime. That person could not and cannot define your creativity or know what is possible, acceptable, desirable. That person does not have a hand on the faucet or the ability to control the flow of inspiration through some talent bank allotment.

Allow the scribbling to flow into writing, drawing, unearthing a message to deliver to any ghosts of the past. The ghost may be a teacher, another student, a sibling or parent, an artist inspiration. No one has a patent on or total control of inspiration, creation, or invention. No one is authorized to deem you "Creative" or "Uncreative." It is time to scribble out, cast out, ferret out the demons and unhelpful commentaries, scripts, and self-talk that may be haunting you.

And if you have no demons—hey, then scribble for the joy of it. There's plenty of nothing to scribble about.

Basic Lines: Ready, Set, Draw!

You are ready, beyond ready. But, come on—have you been repeating the mantra "I can't even draw a straight line"? Well, that's history. Your body

already knows how to draw straight and circular lines. First, work really large—in the air without a marker. Use what you have integrated from breathing and moving. Put large sheets of paper up on the wall (four feet high by six feet long) to practice on. And how about your favorite music in the background?

Vertical Lines

Let your arm drop. Again and again. Inhale as you raise your arm and exhale as your arm falls. Now put a pen in your hand and head for the paper. Repeat inhaling, exhaling, and letting your arm rise and fall, watching as your body creates a vertical line. Experiment with your eyes closed— your arm and body know how to draw a straight line even better with your eyes closed. That means that when your mind is out of the way, you already know how to do this!

Key principle: Go with gravity. Gravity is your friend and will help you draw straighter lines—so start at the top and drop down. Don't believe me, experiment and see for yourself.

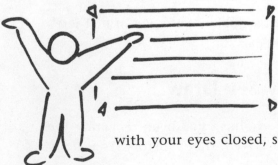

Horizontal Lines

Trace the horizon as you exhale, that imaginary line where the ocean meets the sky, where the desert kisses the midnight blue, where vastness is the creating force and none of man's inventions interrupt the line delineated by nature. Trace that still, solid line with your eyes closed, sense the power in your waist, keep your

knees soft and your focus intent. If you think of something else, you will see a blip in your line, like the pink elephant that you are trying not to think of. Experiment by drawing in one color with eyes open and drawing in another color with closed eyes. See what results you get.

 Key principle: Go in the direction you naturally write. If you are right-handed, draw from left to right. Left-handed, it may be easier to draw from right to left—it's very personal.

Circles

The shoulder serves as a natural compass. Gone are the days of tracing paper plates, lids of pots and pans, and garbage can lids. Now you can use the built-in compass of the shoulder to create huge circles even with your eyes closed. Use large paper on the wall and watch out for marker on the walls. This is fun! Be sure to take that same momentum into the smaller circles—every size works. Alternate working large and small to establish the fluidity of motion at any size.

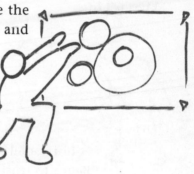

Arcs

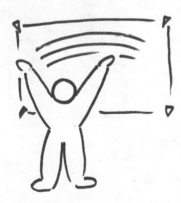

Fix your elbow to one spot on the paper and you will have a natural arc drawing tool. Try lightly with a pencil. Then move your elbow down a few inches and draw another arc—you have just created an arch, perfect to write inside of. How about writing an overarching principle in an arch?

Spirals

Open up the circle and you will find the never-ending spiral. Start anywhere—inside or outside, go counterclockwise or clockwise. Stretch the spirals so that you experiment with elliptical spirals. Now connect one spiral with another...double dancing spirals. We will come back to this later when we start to create scrolls. You are on your way!

Wavy Lines

Knees still soft and relaxed? Breathing helps too. Your body has its unique wave pattern...something like a natural sine wave. Notice how your natural motion has a specific length and spacing to the waves. The good news is the motion is repeatable, works forward and backward and vertical as well as horizontal. Slow down a little if you are having trouble with this.

Begin to trust your muscle memory of the wave rather than your conscious interference or attempt to control the wave. Wavy lines make a great quick and easy frame, border or heading. Connect vertical and horizontal waves to establish a border on your next chart.

Jagged Lines

Same as above—just add angularity. If you add red, it's hot and indicates conflict or anger. If you connect two jagged lines, you'll have a lightning bolt, a flash of inspiration out of the blue....

Fueled with your basic lines and knowing what you know—you can draw from memory. You are

unstoppable now: your body remembers! Your body already knows how to draw. This is the key to speed, comfort, improvisation, and invention. Congratulations!

A PEEK AHEAD TO APPLICATIONS: These lines form the basis of everything else you will draw! The keys you are learning are applicable in all the lines and drawings you make: go with gravity, go in the direction you naturally write, let your body motion fuel the drawing and alternate working large and small. These keys can be applied in drawing, lettering, and life in general.

Shapes

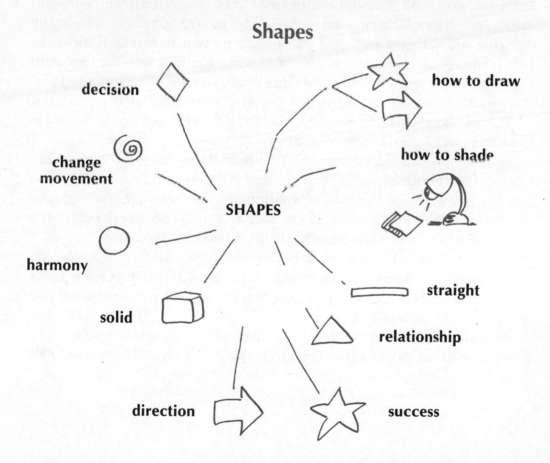

decision

change movement

SHAPES

how to draw

how to shade

harmony

straight

solid

relationship

direction

success

By examining shapes, you immediately expand your ability to depict concepts. Shapes are familiar, easy to draw, and with just a little coaxing, form the foundation of a readily accessible graphic language. Once you are familiar with shapes, you can use them to illustrate concepts and frame groups of words and entire charts. They are your fastest route to a larger graphic vocabulary.

How to Draw Basic Shapes

From the work you have done with basic lines, you already know how to draw these shapes. The same principles apply: go with gravity and go in the direction you naturally write. Let your natural movement fuel each stroke. To help retain the momentum and ease of drawing, alternate working large with working small. Frequently when working small, you are subject to attacks by the inner critic. Alternating sizes helps you steer clear of these attacks.

Circles and spirals—no problem, you already have been doing them. Do some more in all sizes, large and small.

A triangle is two angled lines and a horizontal line. Without the horizontal line, you can invert the angled lines and get a diamond. Slow down here and discover how you like to draw a diamond—is it easier for you to do the top half and then the bottom, or one side and then the other? Establish a repeatable order, so you can create the diamond without thought.

Build a square with two verticals and two horizontals. Notice how you have a muscular memory of line length and height. Experiment for yourself and find the order of creating the square that gives you the most uniform and satisfying, repeatable results.

Dissect an arrow and you find a rectangle plus a triangle. If you want to refine your arrows, start with an open rectangle. Draw vertical lines about half

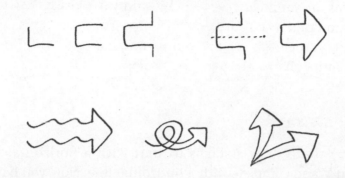

the width of the arrow above and below the open side of the rectangle. Draw a dotted line dividing the arrow horizontally. The angles of the arrow will intersect at this halfway point to form the front point of the triangle. Once you have a sense of these dimensions, you won't need the dotted line because you will have a mental image of it.

Arrows can also be made from open shapes such as wavy lines or curved lines. These are fun to draw and great to indicate flow, forces, and direction. The open arrows have plenty of room inside to write!

If you currently make five-pointed stars with crossed lines, now is the time to add to your repertoire. An open star is a fun addition to your toolkit and gives you a frame to write inside. There are several ways to get at it. One is to trace the outline of your crossed star enough times that you physically start to remember line length and angle. After five to ten times, draw the open star. If you draw continuously in a clockwise or counterclockwise order, you are going against gravity 50 percent of the time. Instead, be willing to lift up your marker. Look for a stroke order that moves from top to bottom and in the direction you naturally write.

Another way to draw a star is to start with a horizontal line, add an upside-down V and complete with a horizontal line. Now you have an anchor and the lines of the inverted V give you a lot of clues. Clue #1 is the width of the V, and Clue #2 is the hidden larger inverted V that defines the legs of the star. Clue #3 is that the midpoint of the V is also the midpoint of where the two bottom legs come together. After you take the star apart and work through it slowly, begin to pick up speed. Keep in mind that gravity helps, and look where you are headed rather than at the actual line you are drawing or the star points won't necessarily close.

Now that you know how to draw these shapes, where will you use them?

For starters, combine shapes with each other and with a variety of lines and squiggles to create borders. Already, you have many more options for borders than you had before.

The hollow shapes (all but spirals) are good frames around words, groups of words, or the entire page. Each of the shapes make great bullet points for lists. As you examine the hidden meaning that each shape carries, draw a list with squiggly lines for what would be writing and use each shape as bullets, so you can see the bare-bones impact of each shape.

Significance and Meaning in Shapes

Shapes are carriers of meaning, much of which is usually unconscious. As you bring forth the meanings associated with shapes, you can choose with awareness which ones to use. Informed, you will have an understanding of the impact and significance of each shape when you use it.

Press the EXPAND button on your graphic vocabulary. As you explore shapes, every concept is one that you can depict with a shape plus the words. There are approximately 20 ideas for each of the 8 basic shapes—that's 160 concepts you can illustrate NOW!

EXERCISE:

Take each basic shape and brainstorm all the places you see it, meanings associated with it, phrases, songs, and colloquialisms. All of these provide hints of meaning. Create a map of your associations, and use variations of the symbols to illustrate each concept. If you can do this in a group, it's fun to get everyone's associations and input. After you have gotten out that first flush of ideas, step back and look for the symbolic meaning—a few key associations that you have for each shape. Highlight these with different colors on your chart.

When you are done (you didn't peek, did you?!), check out the maps that I have here and add any associations you want to your map. I've included some thoughts on the symbolic meanings of each shape.

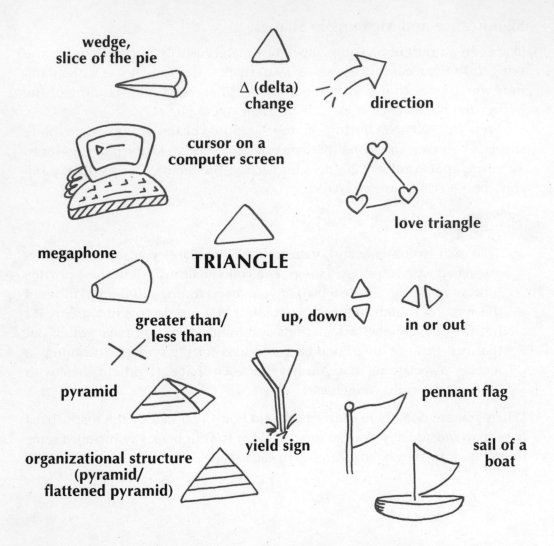

wedge, slice of the pie

Δ (delta) change

direction

cursor on a computer screen

love triangle

megaphone

TRIANGLE

greater than/ less than

up, down

in or out

pyramid

yield sign

pennant flag

organizational structure (pyramid/ flattened pyramid)

sail of a boat

Relationships, order, focus, point, tip of an arrow, funnel, Maslow's hierarchy of needs, gay rights—direction, relationships, focus, hierarchy, movement, change...

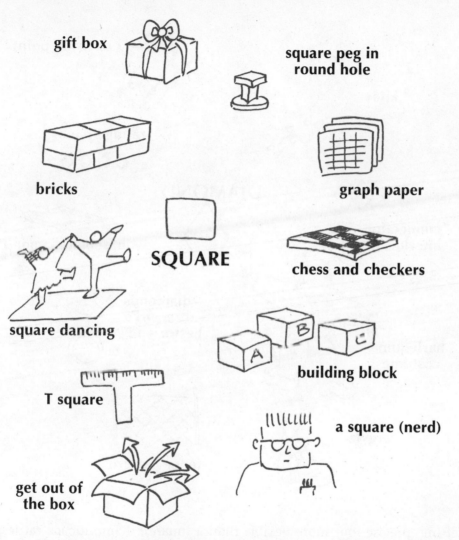

gift box

square peg in round hole

bricks

graph paper

SQUARE

chess and checkers

square dancing

building block

T square

a square (nerd)

get out of the box

Square root, engineers and architects, board games, square one (the beginning), town square (the center), normal, precise, defined, boxed in, functional, cubes, all sides equal, labels, forms, square deal, square meal, square one's account—precision, science, rigidity, container...

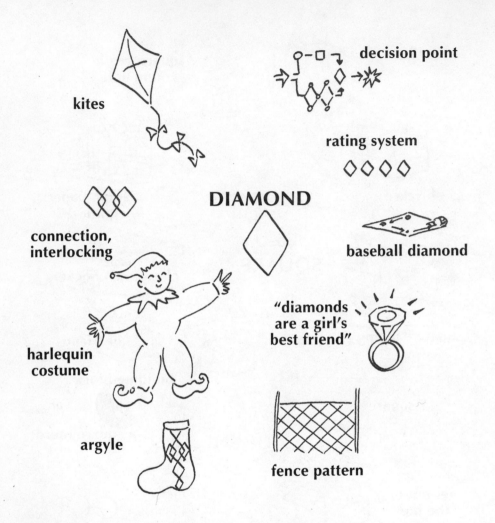

kites

decision point

rating system

DIAMOND

connection, interlocking

baseball diamond

harlequin costume

"diamonds are a girl's best friend"

argyle

fence pattern

Netting, precise (but more flexible than a square), diamondback rattlesnake, clowns, sharp, excellent—decision, strength, flexibility...

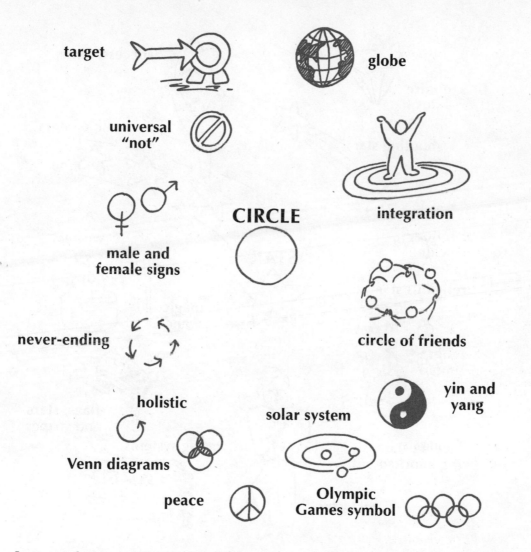

target

globe

universal "not"

integration

male and female signs

CIRCLE

never-ending

circle of friends

holistic

yin and yang

solar system

Venn diagrams

peace

Olympic Games symbol

Inner and outer circle, circle of influence, "circle the wagons," whole-system thinking, unity, equality, inclusive, solution, hole, complete, goal, interlocking, team—wholeness, infinity, harmony...

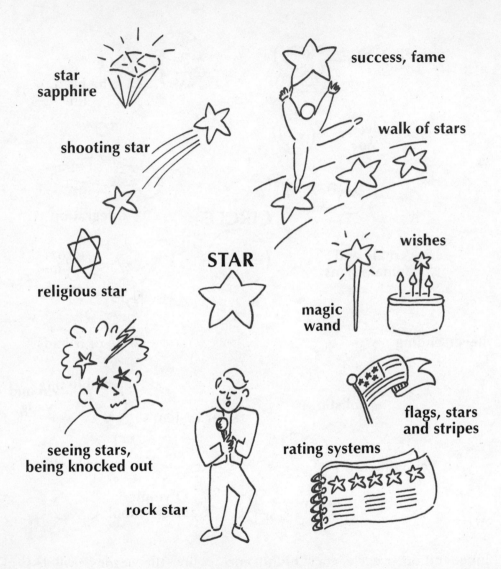

star sapphire

success, fame

shooting star

walk of stars

religious star

STAR

wishes

magic wand

seeing stars, being knocked out

flags, stars and stripes

rating systems

rock star

Magic, celebration, star performer (stocks), happy, fortune, light, The Lone Star State, guiding star—specialty, excellence, celebration...

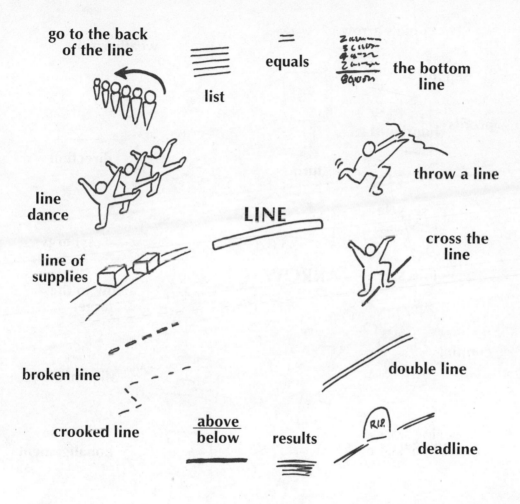

go to the back of the line

list

equals

the bottom line

line dance

throw a line

LINE

line of supplies

cross the line

broken line

double line

crooked line

above **below**

results

deadline

Give me a line, sign on the line, below the line, above the line, what's my line, straight line, line of fire, front line, form a line, draw the line, line up——demarcation, profits, results...

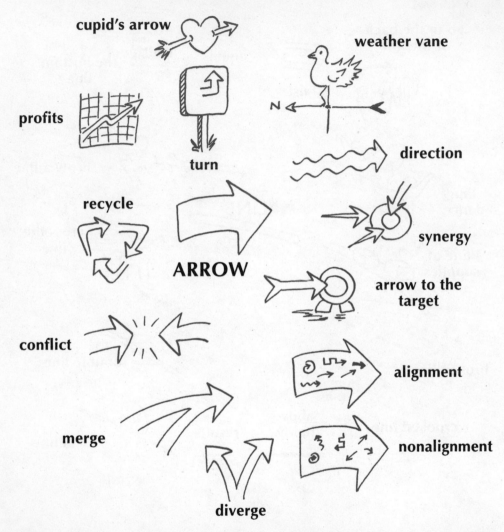

cupid's arrow

weather vane

profits

N

turn

direction

recycle

synergy

ARROW

arrow to the
target

conflict

alignment

merge

nonalignment

diverge

Strategy, alignment and nonalignment, motion, cycles, synergy, growth, change, broken arrow, straight as an arrow, bow and arrow, arrowheads, one way, both ways—direction...

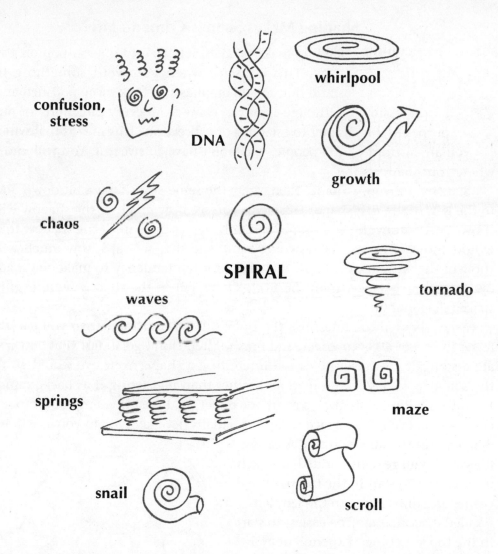

confusion, stress

DNA

whirlpool

growth

chaos

SPIRAL

tornado

waves

springs

maze

snail

scroll

Maze, evolution, transformation, unusual, creative, spinning, life, dance, wild, crazy, infinite, staircase, debt, inflation—energy, motion, change...

Shading Makes Shapes Come to Life!

Shading makes shapes, letters, and objects pop off the page. This is useful when you want something to stand out, to add emphasis or look more polished and professional. Although light can come from every direction, for our purposes, it is simpler to establish one direction. This means that when you are in front of 100 people, you won't have to sweat it. You will know where your shadows are.

Start by drawing a shape. Next, draw the same size shape a bit down and to the left, of the first shape. This helps you see how much of the shadow will show. Now redraw the two shapes and only depict the part of the shadow that would show. However far down you pull the shape, that's how much will show of the underneath shape. Watch out for the tendency to make the shadow shape much bigger than the front shape. Fill in the shadow with evenly spaced diagonal lines.

Now, about those lines: use the thick side of your marker so you can do fewer lines, get an even effect, and finish faster. Don't go so fast that you create a squiggle, because this is too interesting a shape. Your eye would go to the squiggle, seeing it as foreground rather than registering it as background.

Also, shading lines always go in one direction. Resist the temptation to curve them, even if the space is curving. Finally, let gravity help you and draw diagonals in the direction that is easiest for you. If you're right-handed, it's likely to be easiest to start in the top right corner and draw down to the left; left-handed diagonals may be easiest to start in the top left corner. Experiment and find your comfort with this. We will be using shading a lot as we continue.

Color

We are exposed to colors constantly and have culturally specific associations with color. What does red mean? Think how often we see red for stop, green for go, and yellow for caution. Pink for baby girls and blue for baby boys. What of purple, green, black, orange? We have hundreds of associations with colors that are personal and also associations that are culturally, and sometimes cross-culturally, shared.

When you bring your associations with color to a conscious level, you have that much more to play with when considering which color to use. Relax—this is not rule book time. Follow your intuition when picking colors and be informed by the associations you expose here. Color carries emotion like a ship carries cargo. Look for the feeling tones of each color and of different combinations. One of the secrets to a powerful graphic toolkit is understanding and using the impact of color.

Let's dive in first, and then we'll take a look at some strategies for combining, reserving, and managing colors.

EXERCISE:

Take some time with this to gather swatches of material, color, and paint chips. Experiment with pastels, crayons, and paints. Create a large chart (four feet by six feet) for each color in that color, and write key words, graphics, and associations, phrases from songs. Post your chart up and get other people's input, insights, and impressions. Go out for a walk, leaf through magazines, and then come back and add more ideas to your chart. Or create the chart with other people—this is especially fascinating with people from diverse cultural backgrounds.

Some associations are shown in the color charts below. Please add to these, or ignore them altogether and create your own. Afterward, compare the charts and see what's similar or different.

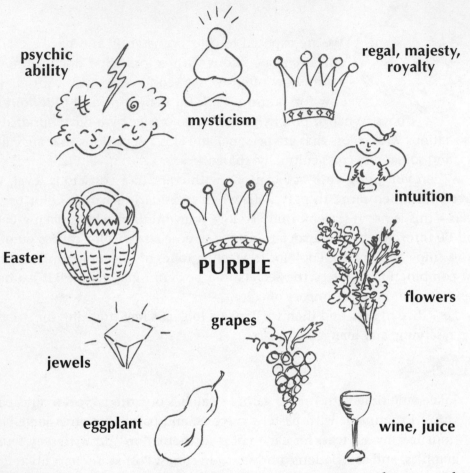

psychic ability

mysticism

regal, majesty, royalty

intuition

Easter

PURPLE

flowers

jewels

grapes

eggplant

wine, juice

Purple People Eater, the Barney character, pansies, power unknown, velvet, jelly popsicles, richness, depth, magical, the Pope's robe, fun, quite powerful, sensuous, motivating, brainstorming, creativity.

Note: Great for generating ideas, brainstorming. This color is easy to read and combines well with everything. If you haven't been using it, what are you waiting for?

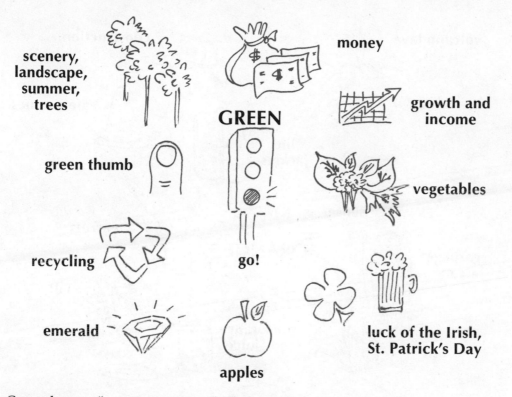

scenery, landscape, summer, trees

money

GREEN

growth and income

green thumb

vegetables

recycling

go!

emerald

luck of the Irish, St. Patrick's Day

apples

Green beans, "eat your greens," Christmas, green with envy, pea soup, gardening, tree (branches coming out of tree show a source of strength), being new, slime, seaweed, moss, mold, *Green Eggs and Ham*, monsters, learning, Kermit the frog, Greenpeace, growth, young, inexperience.

Note: Take advantage of all the positive associations with green: growth, money, health, luck, and nature. Green and brown make a very earthy, strong combination. Branch out as well into green and purple, green and blue, green and pink. Dark green is easier to read, but light green is very upbeat and energizing as well. Walk to the back of the room and check to make sure you can read it easily.

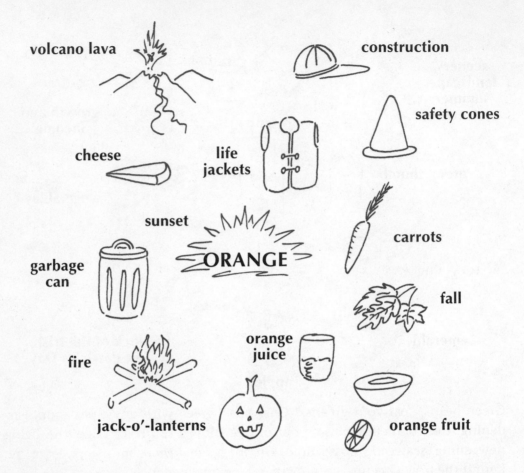

volcano lava

cheese

life jackets

sunset

garbage can

fire

jack-o'-lanterns

ORANGE

construction

safety cones

carrots

fall

orange juice

orange fruit

Reflectors, bright, fresh, hot, Popsicles, caution, hunting, flame, intense, terra-cotta, pottery tiles, signs on the highway, fireworks, excitement, unusual, sherbet, Jello, sweet potato, pumpkin, excitement, clothes in 70s, Dreamsicles.

Note: Hard to read in fluorescent-lit rooms. This is entirely disappointing because orange seems so lively and yet a few rows back, it is invisible. But don't give up—you can use it to highlight and fill in shapes that are outlined in a darker color.

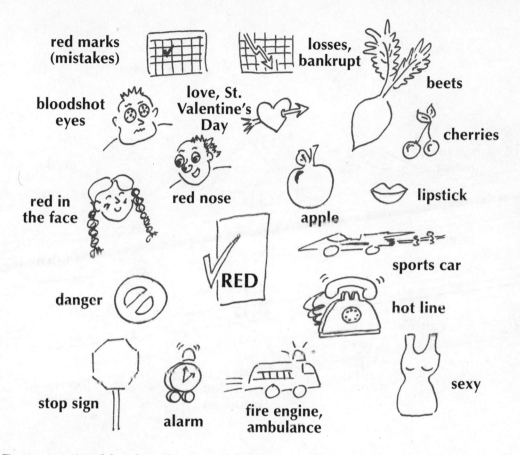

red marks (mistakes)

losses, bankrupt

beets

bloodshot eyes

love, St. Valentine's Day

cherries

red in the face

red nose

apple

lipstick

sports car

danger

RED

hot line

stop sign

alarm

fire engine, ambulance

sexy

Dress, rooster, blood, red wig, red lollipop, power, ruby, fire extinguishers, Santa Claus, borscht, hot, fire, in the red, fingernail polish, red dye #2, dynamite, anger, spicy, chiles, energy, Red Hots (candy), match flame, Red Cross, passion, devil, roses, Cupid, redbird, communism, fire alarm, fire hydrant, a lot of energy, very exciting, passionate, "pay attention to me."

Note: A great highlighter—reserve it for checkmarking, underlining, and identifying hot spots, or areas of tension and conflict. An entire chart of red, or a lot of words in red, tends to push people back energetically and is very hard to look at.

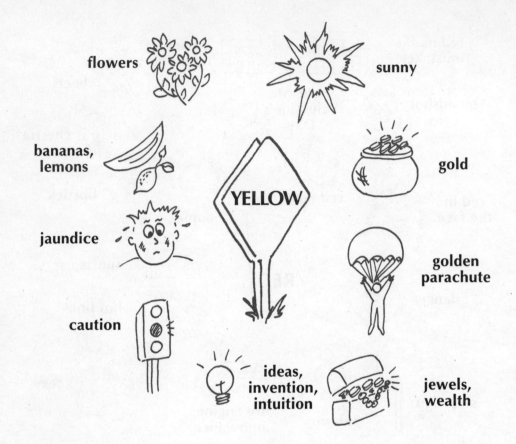

flowers

sunny

bananas, lemons

gold

jaundice

YELLOW

golden parachute

caution

ideas, invention, intuition

jewels, wealth

Bright, happy, golden opportunity, unhealthy, unlucky (in Spain), butter, light, attention-getting, lime green and yellow fire trucks

Note: A great highlighting color and very eye-catching when outlined. Use it to establish order in a messy or very colorful chart by creating fields of yellow for the main categories. It is impossible to see on its own, so outline it or use it to fill in outlined shapes.

Brown

Dirt, tree, wood, skin, hair, coffee, cola, cardboard, leather, logs, shopping bags, poop, hot fudge, chocolate, Hershey's kisses, trees, animals, muddy water, brown eyes, brown sugar, conservative shoes, suits, spices (cinnamon and nutmeg), tobacco, soil, diversity, brownstone house, bread, brownies, smog

Note: Has negative associations in some cultures, so don't use this for obstacles, grievances. An easy color to see and great in combination with green, purple, and blue.

Black

Darkness, bold, black tie, formal, sophisticated, dirt, black hole, black hat, black cat, contract, magic, final, crow, yin and yang, black or white, licorice, scary and eerie, locomotive, smoke, oil, black pearl, in the black, basic black, witch, sexy, black comedy, coal, hostile, death, poison, storming, profits, penguins, nuns, priests, bowling balls, checkered flag, referee's uniform, definite, decision, finality.

Note: A powerful color and easy to remember a few highlighted points in black. Watch for the association with finality—items written in black in a brainstorm may be perceived as decisions instead of options. Check it out!

Pink

Rosy cheek, peppermint, "it's a girl," Energizer Bunny, strawberry shake, pink balloons, pink slip, Pepto Bismol, in the pink, healthy, babies, tropical, flamingos, Bazooka bubble gum, Mary Kay Cadillac, Barbie doll, ballerina, lipstick, pigs, soft, passion, sweet, cotton candy eraser, sherbet, champagne, sunset, pink grapefruit, healthy, blushing, glow, Florida.

Note: Not seen in business a lot, but there is room for it. It's upbeat, feminine, energizing, and fun. Try it in combination with purple, turquoise, or green for moving through the afternoon blahs.

Blue

Eyes, cool, baby boys' clothes, calming, ice, snow cone, sad, blue jeans, ocean, water, glaciers, iceberg, comfort zones, cotton candy, bluebirds, conservative suit, Big Blue, sky blue, tranquillity, solid, rigid, having the blues, once in a blue moon, emotional, uniforms (banking, police, armed forces), pinstriped suit, blue suede shoes, the Blues Brothers, royalty, sapphire, M & M's, Blue Book; dark blue: conservative, more rigid, light blue: calmer, warmer, tropical.

Note: Blue has so many associations with trust, authority, and reliability that it is a good color to start with when you want to establish trust with a group. Combine it freely with green, brown, purple, and use both shades of blue.

Review your own charts as well as the ones in the book. Look for color combinations that could fit certain needs. When you're recording words, it's easier to read if you alternate colors. (For more on this, look up "Basic Organizations: Lists" in this book). Look for color combinations that support what you are sensing in the group.

Conservative, need to build trust:

Dark green/brown—earthy

Navy blue and dark green—sky and earth

The two greens—solid growth (money) and new growth

Navy blue and purple—serious, but let's stretch into creativity

Falling asleep after lunch:

Turquoise and purple—tropical and creative

Turquoise and light green—upbeat and growing

Purple and pink—playful, a party

Dark green and raspberry—grounded and juicy

Need action items:

Red check marks

Red outlines

Yellow highlights

Black outline or writing

EXERCISE:

What color combinations would you use for these situations?

Urgency

Highlighting

Caution

Brainstorming

Tension

One Friday afternoon when I was just starting, I was in a very highly charged meeting. Tension was thick and buzzing like electricity during a summer storm. It was the worst time for a meeting, the boss ran the unit with an iron fist, and no one wanted to be there or speak up. I was nervous and not using many drawings, just trying to capture people's words and keep breathing. What I was doing (subconsciously at first) was using pink and purple to write in. After about the first hour, when the room was papered in pink and purple, people started relaxing, speaking more freely, joking, and even voting in public. It wasn't the only ingredient to support that change, but I chuckle when I think back to discovering the impact of those colors.

HERE ARE A FEW MORE TIPS ON COLOR: As you enter a new section in discussion or training, switch to different colors. Consider new color combinations an infusion of energy—it's one remedy for a low-blood-sugar group.

People tend to attribute likeness to information written or outlined in a similar color. Use and also watch out for this tendency. When you are working with a group, save one or two colors for highlighting and making connections.

Experiment with using black to outline lighter shapes and letters. A thin black outline around lighter colors defines the shape and makes it pop out more. It is much easier and quicker to draw the shape first and then add an outline around it.

When you hold the markers, it is easiest to keep the tops of the markers off. This keeps you from fussing with pulling off tops and losing several seconds, but it also may increase your dry cleaning bill. If you hold the markers between your fingers—one in between each finger of your non-dominant hand—then you can pass markers back and forth to your writing hand. Experiment with holding the less used highlighting colors between your little and fourth fingers.

Keep in mind that this is a loose and intuitive guideline. If you don't personally like any of these suggestions, don't use them! Be sure to check how well the colors show up in the room you are working in. You may need to say farewell to only using black, blue, red, and green. There is so much more strength and impact when you use the full spectrum and diversity of colors.

Lettering

Consider lettering as a graphic that just happens to be words. Lettering is a graphic element to play with. Get comfortable with variety and options. Size, style, color, and placement all contribute to the way a chart looks.

Upper- and lowercase printing or all capitals are the easiest to read. If you get going too fast and start cursive writing, it's much harder to read—all the letters flow together. Italic writing can look like you're racing along in a hurry. The feeling of an entire chart is shaped by the lettering, so it's helpful to feel at ease here.

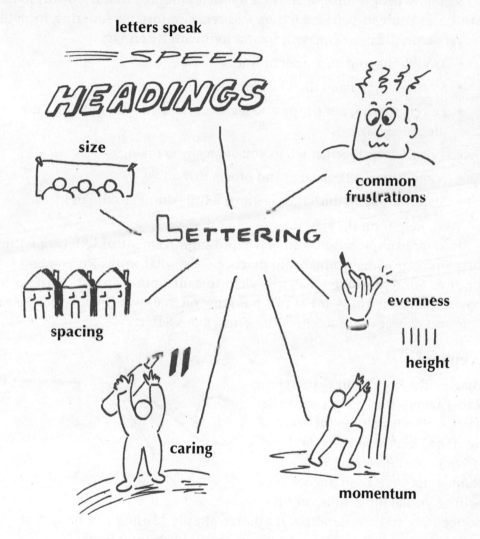

letters speak

SPEED

HEADINGS

size

common frustrations

LETTERING

spacing

evenness

|||||

height

caring

momentum

So many people are embarrassed by their lettering, that it's worth looking into here. You can befriend letters and feel comfortable lettering in public. What are the most common frustrations with lettering?

- Trouble staying on a straight line
- Starting higher and then heading downhill or the reverse
- Letters starting out happy and legible, and then deteriorating into illegible scrawl
- Tying letters together when you are really cranking
- Some letters getting large and others tiny
- Slanting way to the left or leaning, a little drunk, to the right

Well, help is on the way!

Here are simple suggestions for rapid improvement of lettering without the pain of grueling penmanship practice. Take what works for you and leave the rest. Some of these ideas will yield instant improvement, while others may feel awkward or weird at first but grow on you over time. Let's take each issue and dissect the problem of those rebellious letters.

Evenness

Imagine the horizon line, stretching across where the ocean meets the sky. Use the little finger if you are right-handed, or the side of your hand if you are left-handed, to serve as an anchor pulling you along a horizon line.

Notice how you are standing. If you are already leaning or off vertical, your horizontal line will be more of a vector than a horizontal line.

This little finger technique helps several things—for starters, it ensures a connection with heading across the page at a relatively even level.

Height

Once you have the little finger on the page, it forces the height of the letters to be uniform enough—and it turns out to be about an inch high, which is a great height for working with groups of up to twenty-five people. Practice creating mini-verticals, or miniature versions of the larger vertical lines you practiced earlier. If you move the finger while you are making the lines, you won't get the benefit of this. The finger moves a tiny bit, but mostly it is a steady guide across the horizontal. The little finger anchor will assist you while writing capitals or lowercase letters but doesn't really help for big letters such as titles and topic headings.

Momentum Works in Small Spaces Too

Using the momentum of body movement works when you draw big lines and now your challenge is to take that into the delicacy of letters. It helps to alternate working large and small, tapping into the momentum and then applying it to a smaller stroke. Go through the whole alphabet and find the basic verticals, horizontals, diagonals, and curves. Every letter is composed of these. Also look for where you can simplify—additional curves, curlicues, and embellishments take longer and are harder to read.

Lettering Is Hand-dancing

Lettering is hand-dancing, involving the whole body as the motion pours through the hand. Use your inner checklist to stay in touch with soft knees, breathing, loose neck and shoulders, and an awareness of your back, arms, and legs...

If you move your hand in isolation, you will tire more quickly. Sense how your entire body supports the arm, and you will have more energy to keep on dancing. Even as you are focusing on the hand motion, stay connected with being rooted in your legs and present with your breathing.

Letters Respond to Caring

You can throw lines away or you can care about them—this is the gap between a scrawl and calligraphy. If you hold a chisel-tip marker so that you get a thick line, you also will get an angled ending to the lines. This effect is pleasing to look at. Also, thick-lined letters are easier to read and appear more confident. If you still have sad-looking letters, slow down and care about how you are creating them. Letters give you immediate feedback. You will enjoy what you hear and see by slowing down even more. Don't worry, you will be able to speed up again later.

Legibility Arises Out of the Squalor of Scrawl

Imagine that each letter lives in a house, which is evenly spaced from the next house. Yet another house is the space between words. Within each letter of the alphabet, some letters are fatter (M, W, O) and other letters are more svelte (I, L). Experiment, as architects and calligraphers do, with an equal height and width to letters...you really need to slow down here.

Keeping this housing image in mind, find out where you have a tendency to connect letters. Connecting letters into script form is very difficult to read.

Squished Letter Syndrome

Have you ever started out on one side of the page, feeling great and confident, only to end up with all the letters squished at the right-hand edge? Here's a trick, especially for pre-charting, to help avoid the squished letter syndrome.

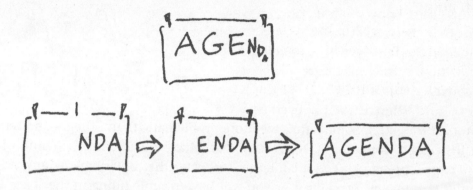

Count the number of letters in the word, including any spaces between words. "Agenda," has six letters. Start in the middle of the page and write the right half of the letters (N, D, A). Go back to the middle and write the first three letters, starting in the middle of the word (E, G, A). If you have a tendency to scramble words anyway this might be fun for you—if not, give it a try anyway.

I bet like most of us, you also squish letters when you are trying to fit a word into a banner or box. The simplest remedy is to write the word and *then* draw the shape around it. The centering technique is useful for already drawn shapes that you want to fit words into.

Size

The size of letters can have a big effect on a group. If the group can't see what you are writing, they will stop looking. If the lettering is too big, participants may feel pushed away. Be sure to check that your headings are legible from the back of the room—for large groups (100 plus), you need about four-inch letters.

Headings

An easy-to-read lettering style is out-line letters. Discover how to create an outline by drawing the regular letter (consider this a backbone of the letter), and then draw an even space

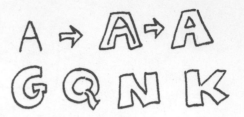

around the letter. Some letters are more problematic than others—and require a little more care—G, Q, N, K, and S each have specific needs. Think of the space you are creating as a container for water that flows equally around the letter shape. Not too skinny, or you will have trouble filling in the space with color. Once you figure out how to draw the outline letter, you don't need to draw "the bone" anymore.

Let the Letters Speak

Letters are a graphic component too and sometimes when you can't think of a picture or icon symbol, it's not just okay but a good idea to use the word. Make the word bold or do something to the formation of the letters that expresses meaning or emotion. Here are some examples: speed, change, melt, hot.

Warning: Frequent sightings of the inner critic occur in the land of lettering. So beware—if that happens, use big strokes in the air or on paper. And see the chapter on talking back to the inner critic!

Basic Concepts, Part One

These basic images are quick to draw, so that you will use them right away. They comprise a beginning toolkit for concepts that come up frequently in many meetings. You will find that these images are fluid and can be used to depict a variety of ideas. Remember too, that you already have all those concepts you can use shapes to illustrate.

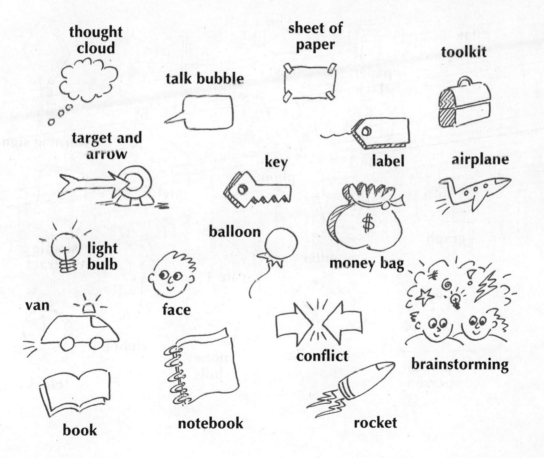

If you are worried about not being able to draw images quickly enough, one way to start is to pencil them lightly beforehand and then draw with a marker in real time. This will give you confidence in working in real time and also provide the support you need at the beginning. It also gets you drawing the images. Sooner or later, you will leave the pencil drawings just as you left training wheels while learning to ride a bike.

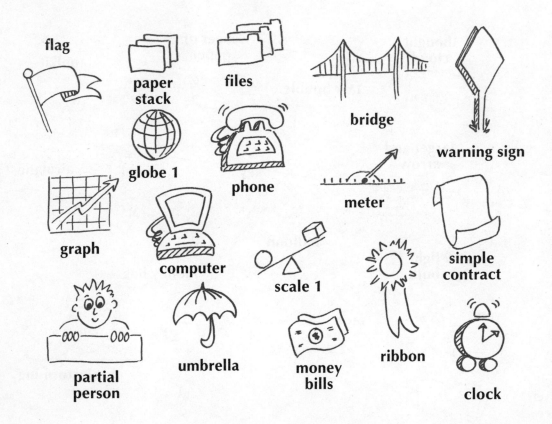

flag

paper stack

files

bridge

warning sign

globe 1

phone

meter

graph

computer

scale 1

simple contract

partial person

umbrella

money bills

ribbon

clock

Even in this beginning toolkit, pick out the ones that are profoundly simple: the talk bubble, thought cloud, light bulb, notebook, graph, clock, umbrella, and money bills. Start with these and work on speed. While doodling and practicing on your own, integrate more images that would be useful in your field. Work to bring these to your repertoire of images. You are going for ease and speed—just the way you sign your name. You're ready. I know you can do this!

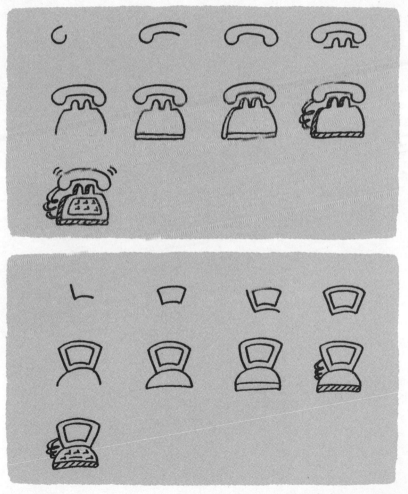

Here are a couple of tips for when you are practicing these concepts. Go with gravity, go in the direction you naturally write, alternate working large and small, and bring your movement momentum into the small drawings as fully as into the large.

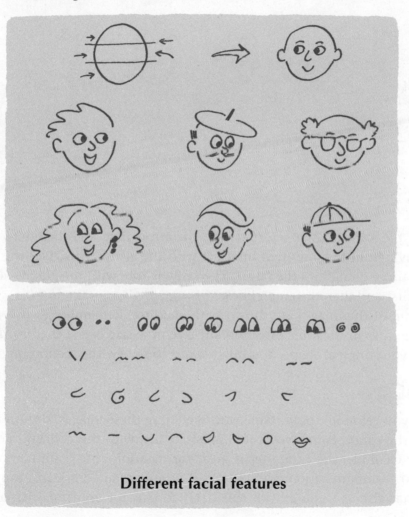

Different facial features

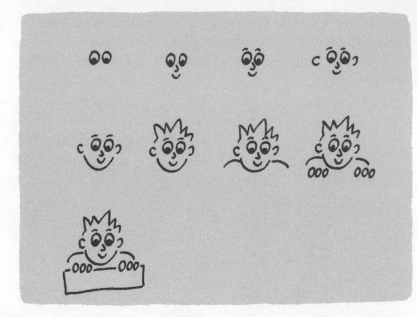

For the arrow and target, start with the arrow first, and then draw the target, leaving out the lines that intersect with the arrow. This gives the illusion of the arrow going into the target. The same is true with the graph—draw the arrow first and then the graph lines.

Some of the images are shown with shading. Remember to draw all the shading lines in the same direction and keep the size of the shadow the same size as your original shape. You might want to review the section on shading.

EXERCISE

As you get more comfortable with sketching these images, start to think of all the concepts that you could illustrate just with this collection of icons. For example, the computer is great for technology, e-mail, computerization, communication, computerized finances (add a $ sign), input data. What else can you add to this list? Do this for yourself with all these

images. Now, go back and brainstorm how you can use this toolkit (remember to also use the basic shapes) to illustrate concepts not listed, such as downsizing, opportunity, communication, focus, profits, speed, or regulations.

Make a list for yourself of these concepts and carry it with you—practice in your journal, waiting in lines, on the airplane, in the hotel, on the patio, at your desk, or kitchen table...Doodling is relaxing is fun is linking to moving is doodling is practicing and helps you to keep practicing and practicing and doodling and practicing...know what I mean?

Using a graphic language has no limits, and your mind, imagination, and courage can create even more applications than are mentioned in this book. Once you start, you just might keep going—so watch out!

Whatever you are doing, magnify it. Many people initially think of graphics as adjuncts to the words. Start to create graphic sandwiches—the graphic is the "bread" frame and the words are the center content. This bite-sized morsel is eaten by the mind, digested and absorbed. The good news about graphic sandwiches is that you can write the word first and then draw the graphic around the word—no squished letter syndrome!

Take each of these images and brainstorm several concepts they could depict. This is one way to increase your graphic vocabulary, by using the same images in different applications.

Basic Organization: Structuring Information

Staring at a blank page can be intimidating, especially with thirty or more people watching what you are about to do. Why not have some options in mind for how to deal with a blank page?

You may be used to working on flip charts, but look out. The majority of ways to organize information will compel you to work on larger charts. These charts can be created either by working on several flip charts or on sheets of four-foot-wide paper that is cut to six-to-eight-foot lengths.

How you organize information depends on the complexity of content, how you want to support a group process, and your intuition. These underlying structures will help you plan and confront a blank page with some options in mind. Think of these structures as inner architecture—the bones of information. Each structure supports a body of thinking and gives shape and form to a stage of group process.

Conduct an overview of all the structures and recognize the function each one fulfills. Each one supports a phase of idea generation and development. We will be looking at the first five in depth, but you can start the overview now.

- One idea on a poster—a focal point

- Sequential ideas—in lists—vertical organization

- Related ideas form clusters—radial organization

- Tighter relationships in grids—vertical and horizontal organization

- Grouped relationships inside simple frames——gathering information

More complex structures depict more complex relationships:

- Branching relationships in diagrams and mindmaps

- Multidimensional relationships in maps, metaphors, or landscapes

- Holistic interconnection in mandalas, radial organization

As we look at the basic structures, look for what dimension of thinking each one supports. Some are opening, supporting divergent thinking, such as clusters and mindmaps. Others are closing, providing structure for convergence or organization, like grids and mandalas. Posters convey one idea, while nonlinear connections in drawings and maps integrate many diverse ideas into a broad framework.

With these basic organizations, you'll get familiar with the raw materials that support and shape discussions. When you progress into more complex structures, you'll integrate these basic ones and also create new combinations. The good news is that you already use these first five organizations on a regular basis. As you bring these structures to conscious awareness, you will have more options for mapping information.

One Idea: The Poster

This is a single theme integrating a visual image with words. Letters alone can also be the "graphic" for posters. Examples abound in covers of magazines, books, poster art, billboards, and comic frames.

The poster organizes information around one idea using elements of color, size, lines, shapes, frames, lettering, and perspective to capture attention. The goal is to clearly guide the viewer to a powerful, punchy, and memorable message.

Use posters to introduce a topic, focus a group, underscore an idea and create a theme. Posters make good welcome signs, advertising concepts, highlighted sections of a course, reinforced key points, and logistical information such as telephone numbers or to signal a break. Visually reinforce themes with posters of process points that you want people to see throughout the day. Posters around a class or meeting room are seen repeatedly and help subliminally emphasize learning points and key concepts.

In trainings, I start with posters around the room to help create a supportive and creative environment. Posters with graphics and words remind and

encourage participants to take risks, have fun, experiment. In facilitations, I frequently create large posters on the spot to reinforce opinions, audience participation, votes, etc.

EXERCISE:

Make a poster for an upcoming class, training, or presentation. Make one for your desk, home, or refrigerator. Use the examples below to give you ideas for your welcome poster or theme reinforcer, topic heading, or process reminder. Work quickly and with large graphics so that you can get comfortable with creating posters live.

Include in your poster: a focal point; an arrow or eyes, hands, or other object that points to the focal point; something that goes outside a frame; a frame; minimal words with some highlighting of the words through outlining or interesting calligraphy or color. Draw whatever is most in front first, so that you can draw the border around the object. Success in a poster is ONE undeniable and memorable message that comes across for the viewer.

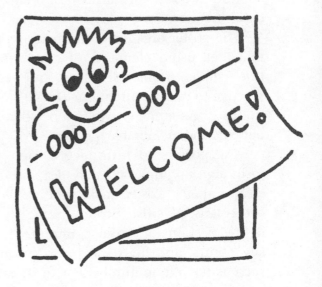

Play with borders for posters and then use these for any other charts. Draw twelve to twenty boxes and create borders with lines, squiggles, or shapes so that you have several borders you can repeat quickly. Also consider framing with objects to look like a window, picture frame, theater

stage, or wooden border. Depict oversized thumb tacks, nails, taped paper, paper clips and old-fashioned photograph borders to add variety for poster design.

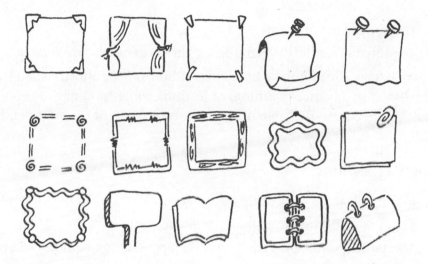

Sequential Ideas: Lists

I bet you already make lists—to-do lists, shopping lists, agendas, and discussion topics. A list is a vertical organization of ideas that may or may not be linked to each other. Often the ideas are not linked. You probably use lists so much that as you learn other options, some of the things you are currently listing you'll begin to capture in a different form. Lists are great to:

- Define agendas
- Record group expectations
- Establish ground rules for a meeting
- Identify meeting objectives

- Capture discussion
- Record a brainstorm
- Evaluate pros and cons
- Identify action items
- Commit to action items
- Capture tangential or "parking lot" items to be discussed later.

Because you already make lists, the method is fast, effortless, and doesn't require thought, advance planning, or learning something new. Keep using it! In addition, begin to use some of these ideas to make or create order, legibility, and visual interest.

Listing Suggestions:

- Write a clear, bold, big title.
- Use boxes and frames to create topic headings.
- Use bullet points; pick from all the shapes (circles, squares, triangles, spirals, diamonds, stars, arrows, asterisks).
- Alternate colors for each line.
- Add thin lines and space to separate lines of words.
- Leave space in margins for inserting information later (names, times for who will do what by when).
- Add color and graphics to make topics pop out.
- Insert check marks for to-do items.

For logistical ease, start with three colors—one color for the bullet and the thin line between lines of words and alternate two other colors for capturing information. When I started doing this, I'd panic if I mixed up the order—I'm sure this fits in the category of "Don't sweat the small stuff"—and I was the only one concerned about this. Of course, while I was worrying about color

order, I didn't even hear what participants were still saying. I learned to let go of perfection and stay true to participants' words. The colors will sort themselves out.

Experiment with combinations of colors—green and brown for earthiness, purple and anything, blue and green, the light blues and greens, and dark blues and greens. Have fun with this. Save your highlighting colors (red, orange, yellow) for emphasis. Look back over the color chapter if you want to review the impact of these colors.

Watch out: Numbers in front of comments make ideas look like they are ranked in importance and dashes for bullet points may look like minus signs. To bypass these interpretations, use graphic symbols for bullets, such as asterisks, circles, triangles, spirals, diamonds, arrows, or stars.

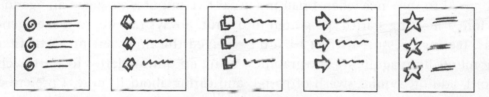

If you are working on a large chart, you can thinly outline the size of a flip chart around a list, to enhance clarity of flow and recreate the feeling of moving from page to page. This also helps you to use large paper but feel the safety of having some border already defined.

EXERCISE:

Create a to-do list for yourself and integrate as many graphic elements as possible. That means make the title powerful, shade bullet points, alternate colors, use thin lines, add graphics, experiment with graphics around an entire phrase, and number the pages as you go.

Now, create an agenda and put each line of the agenda inside a graphic that depicts that section. Use color and variations in lettering for more oomph.

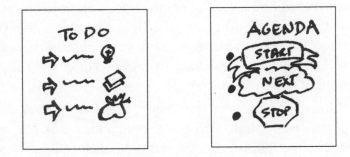

I especially like having graphic frames around sections of an agenda. This occurred to me once when I had my usual five minutes to create an agenda before a meeting started. I'd gotten into a rut, always rushing to make agendas, feeling pressured when I hadn't received the final version until that moment. By magnifying the graphics, using an outline letter to start each word, adding a quick swash of pastel, and caring about it more, I preferred what I finished up with. And it took the same amount of time!

Related Ideas: Clusters

Clustering is a loose, flexible organization where ideas are loosely grouped with related ideas clustered together. From this structure on, a flip chart feels too confining, so this is a good time to start working on larger pieces of paper!

Start with paper that is four feet wide, cut in lengths of six to eight feet. I like to hang these two or three deep and two across, creating a twelve-by-fourteen-foot surface to work on.

Clusters often emerge in two phases: first, a flood of ideas, usually with some obvious connections; second, step back and look for more connections. If there is a gusher of ideas related to one area, you can start another cluster.

Discussions frequently jump around, moving from one topic to the next and then back again to the first. Clustering allows you to follow the flow of a group discussion without having to impose any organization too soon.

Start anywhere on the page. Get relaxed with not knowing where you will go next. In the rare event that a group knows topic headings in advance, let them guide you to placement and the amount of space to allow. If the group session is open-ended, start anywhere and remember that you can always add more paper. Have a flip chart nearby to spill over to if the group goes into great detail in one area or if you run out of room on your chart. Be aware that using the same color for related topics may superimpose connectedness before the group has defined the linkage. Save a color or two for the second go-around to illustrate connections.

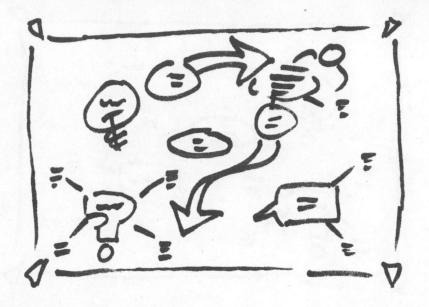

Clusters are great for lively brainstorming sessions. They quickly become chaotic and messy. This inherent messiness encourages creativity as well as seeing fresh connections. When a group is rolling, clustering opens up space around ideas, supports making connections and recognizing emerging themes. Because the form is so unstructured, it is easy to work rapidly and keep pace with a gusher of ideas.

I use clustering for brainstorms, discussions, and times when a group is getting a broad view of information and opinions. Because there is more space around topics, it is easier for the group to see and point out relationships. Initially, the scariest thing for me was to not have an idea of what part of the discussion will expand and what will be just a small, tangential point. I still don't know, but I am more comfortable with these options: draw big connecting arrows, add more paper, start a new chart, take detailed notes on a

flip chart, wait a bit before writing to listen more for the pulse of a discussion. It is quite magical to watch a chart take shape, especially when an organization emerges in discussion that is matched in the chart. Sometimes, well, the chart is an accurate reflection of the pure chaos of group discussion.

Clustering works well as a way to capture a brainstorm with predefined categories. This method is especially useful when you know the themes, and it can be used for preview, review, or testing. For example, if you are coaching team development, you could draw out the main categories, such as developing trust, communication, respect, a shared sense of purpose, and reward or recognition. Draw side-shoots off each category to show related but more detailed subpoints. Afterward, as an exam or review, you could create a cluster drawing with five categories. You might leave some drawings, headings, or color as hints and participants could fill in the rest of the categories and also the top related points. By repeating the same format to display information, you help participants remember the content visually and spatially.

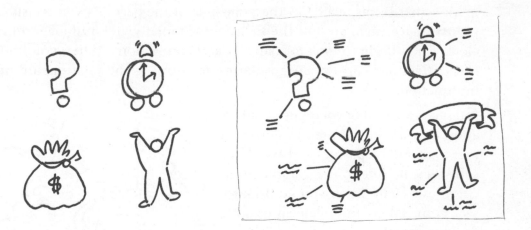

This is a very versatile form with countless variations. Combine clustering with listing if the group goes into greater detail. Feel free to move back and forth between large charts and flip charts. After the whoosh of a brainstorm, emphasize connections by linking ideas with colors and graphics. Wait to draw in the connections until the first round of idea generation has occurred. Use the pauses to also finish a half-started drawing, add illustrations, strengthen lines, or fill in shadows.

Take a look at some of the things you normally list, and experiment with depicting the same information in a cluster diagram: expectations, goals, evaluations. When the same information is mapped as a cluster instead of a list, you will get more input and more relationship-seeking from participants.

EXERCISE:

For yourself, map out an upcoming speech, presentation, or training in a cluster format. Get comfortable with the freedom of working on big paper and mapping information spatially rather than in lists. At first put information that seems related in the same area of the page. As you see subpoints, place them around the main point radially, like numbers on a clock. Then begin to look for patterns and connections. When you find links, draw large arrows encapsulating or showing the relationship of information.

Interview a friend or colleague about a situation they are in and use the cluster format to identify top issues and associated subissues. Be sure to use graphics and color, especially when you go back to seek connections and establish priorities. Be patient with yourself; the indoctrination in linear list-making has deep roots for

some of us and you may find yourself listing automatically. With time and practice, clustering will feel more natural.

Grids

Let's get organized! Grids are interrelated boxes of information with topics intersecting in uniform squares in a matrix format. Think calendars, charts, and project planning. The elements are aligned both vertically and horizontally, and this format exudes neatness and organization.

You already use grids in calendars, charts, graphs, and schedulers. Grids focus systematically on relationships. They lend themselves most readily to analytical thinking and can be used for those situations that require or invite this mode. When a group is struggling with focus and commitment issues, think about using a grid to help them identify all the areas they need to consider.

Watch out: The group must clearly define topic headings—and be sure that the categories are correct. It is easy to assume connections once the momentum of working in this framework is activated. If there is a glaring absence once the grid is complete, no one will want to redo it.

On the other hand, be aware that a grid is death to a wild brainstorm. Because this structure is so much about focus and precision, this is the opposite of the unlimited thinking you want to promote in a brainstorm. However, grids are strong medicine when used at the right time.

Experiment with using color and symbols in addition to words in your grids. Enhance grids with Post-it notes or shapes with Post-it glue on the back so that items can be moved during discussion. Prior to your meeting, draw the icons in black, leaving enough space to write inside each icon (at least four by six inches). Photocopy these on different colored sheets of heavy (card stock) paper and then cut the shapes out. Preglue the shapes lightly onto regular copy paper and store each type of icon in plastic bags. At the

meeting, you may need to add some glue, so assign a helper to deal with the management of icons. The grid is a great tool for planning and scheduling, such as coordinating multiple efforts for strategic planning.

I've used this method with department executives for coordinating annual strategic planning across departments. The grid was created with the quarters of the year across the top, the departments along the side, and projects captured on Post-it notes. This made it easier to track the lively and heated discussion about duplication of effort, sequencing of events, and allocation of resources. For a discussion like this, have a flip chart handy to capture the discussion and critical issues that don't fit into the project categories.

EXERCISE:

Experiment in an upcoming meeting where you are seeking closure and generating commitment. Practice creating a grid for a series of tasks that you need to evaluate.

Use a grid with a group or team when you need to clarify who does what task. See if you can start with a grid that is not overly complex, so that you can have a fun time creating it! This can be as straightforward as a series of tasks for the week.

Frames

You can use simple shapes to create graphic frameworks for information. These graphic elements can give you a great starting place for capturing information.

Begin using frames by predrawing shapes in which to capture information. Here are some ideas to get you started. As you get more comfortable with using frames, you will be able to do this live.

To capture comments from a group, predraw a chart with blank talk bubbles and frames and record comments inside. When you want to find out

what people are thinking, create a similar chart with thought bubbles and then capture responses inside. If you are discussing change and what people need to leave behind in terms of personal or organizational baggage, outline suitcases, backpacks, trunks, and boxes to symbolize the baggage. Write comments inside the luggage shapes as participants describe what they want to leave behind. In very charged situations with lots of emotion flying around, draw a huge chart that simulates a wall of bricks. Write across the bricks and inside them, in a loose style reminiscent of graffiti, and help the group speak the unspeakable.

To vary the process, have participants write their own comments inside the frames or have people write comments on Post-it notes and place them on the chart. This creates more anonymity while still promoting involvement.

As you get more comfortable drawing in front of groups in real time, you will organize the chart space leaving room for frames. This actually gives you much more freedom than working within predrawn frames and is a dramatic way to connect information. Drawing the frames afterward makes it easier to accommodate longer and shorter comments.

In a departmental strategic planning meeting, participants were evaluating their departmental strengths and weaknesses in a number of areas. I had drawn a character for "strength" holding a barbell and a similar weak character struggling with a smaller barbell. I then listed the different areas of strengths and weaknesses positioned near each character. As I finished capturing comments, I realized that these areas were not separate, but interlinked. I had just enough room to draw puzzle pieces around the sections or comments—creating a dimensional frame in a color I hadn't used yet. The whole message of the chart came together with that finishing touch.

In a focus group where people were discussing what information they needed in a computerized directory, I captured the information in lists and then drew computer frames around different options. Putting the list on the

computer screen made it seem more realistic as an option. Because I had this in mind as a plan, I made the lists relatively similar in height and width so that the options would seem equivalent. Keep in mind that if one image is much bigger than the others, the size seems to indicate a preference.

You will begin to see opportunities for frames, including linking related information with puzzle pieces or hexagonal shapes like a beehive; drawing talk or thought bubbles after you have recorded the comments; drawing arrows around action items and keys around key strategies. Look back over any hollow shapes and icons you already draw regularly and brainstorm new possibilities for using these shapes as frames.

EXERCISE:

Create a comments sheet with predrawn talk bubbles and add heads and shoulders across the bottom of the sheet. Bring this to your next meeting or training and record comments inside the bubbles.

Draw a page of bricks in red and brown. This can be as simple as a series of rectangles. If you want to add more dimension, peek ahead at the "No-Brainer Perspective" chapter for some tips. Get pastels and fill in washes of color to add more depth. Use this to record comments about concerns,

problems, and issues. Draw across the bricks with abandon to recreate the feeling of graffiti.

Record pros and cons, or strengths and weaknesses—any type of opposition. Leave room around areas within the subtopics to draw interlinking puzzle pieces. To make the puzzle pieces stand out, use a color that isn't used elsewhere on the chart. If you are feeling ambitious, add dimension along the edges of the puzzle pieces.

Look over the images from Toolkit 1 and pick hollow shapes and images you want to start with. If you have been in meetings in the last month, think back over where you could have used these frames to create clarity and highlight information. Now, pick several frames to use within the next two weeks.

Toolkit Two

Way More

• Toolkit Two •

By now, you must be feeling better! You are over the first hump, you have a larger graphic vocabulary, and you have practiced using the first toolkit with yourself, friends, and coworkers. I bet they are delighted and have encouraged you to keep going. At this point, you really have enough to map out meetings, discussions, and trainings for a year.

But wait, there's more! This second toolkit is where your understanding deepens and you can stand in confidence with your developing skill. Yes, there may still be many times when you feel awkward. Why wouldn't you? You're doing something new!

Help yourself by creating opportunities to separate out the graphic recording role. This will give you a chance to give your undivided attention to creating live graphics and capturing essential words. As you get more comfortable, this ease will carry over to when you are using the graphics *and* facilitating or training. (A series of successes is more likely to keep you coming back for more than one big event where you felt in over your head.) This is the toe-in-the-water-of-the-swimming-pool-before-swimming-the-English-Channel method.

Drawing out ideas happens in stages. The most helpful thing to do is be compassionate with yourself. Set up support with the people you are teaming up with. Establish a graphic language group and practice together. Involve your department, team, or family. Use the practice suggestions to help you gain experience and confidence.

As in any language, the challenges change as you learn more. Now you have some insights, vocabulary, and options for organizing information. At this stage, you may start to hear words and think of more visual images than before. That's good news! *And* now you must start to preselect the simplest

images, those that are quickest to draw. This develops fluency—the mental fluency to match the concept with a simple icon and manual speed to whip out that icon as easily as you sign your name. Your challenge here is to thank your subconscious but relinquish elaborate images—keep it simple.

Additional challenges of this stage are expanding your toolkit of images and drawing slightly more complex sketches quickly and effortlessly. As your drawing fluency increases, your attention is freed up to watch what is happening in the group. Attention shifts from your internal struggle with graphic vocabulary to being available to examine other dimensions of perception. Calmness, patience, and practice are your best buddies. Let's go!

Accelerated Learning Theory: Getting Started with the Senses

How do we remember information? With all our senses! This means we associate pictures with concepts, colors with significance, sounds with memories, physical actions with specific information. Accelerated learning theory states that people remember and learn more effectively when information is presented in more than one sensory modality. The power of the visual is that the vast majority of people are primarily visual thinkers, so we are prime candidates for the billions spent on advertising, television, media, film, and multimedia.

Here are some examples of the power of visuals. After one meeting, when the charts were already en route to the printer and the group wanted to remember what they'd discussed, we were able to piece the information together by remembering the graphics—something we never could have done if we had just captured the ideas with words. Another time, people started referring to their departments as "huevos" and I drew fried eggs all over the chart. I don't know why it was "huevos," but the group came together around that theme and referred to the "huevos" discussion well into the next year.

People remember pictures. They also remember the creative act, a metaphor for going from a blank page to a chart that was shaped and formed by their input. This becomes part of the group experience, to create something significant rather than just having another boring meeting. A spontaneously created live depiction can match the group's needs and direction. This has a entirely different dynamic and group impact than premade information overload.

The field of accelerated learning is an entire field of study examining how to access all of the ways in which we learn and remember information. One way you can enter into this study for yourself is by examining your senses— what do *you* hear, see, feel, smell, touch? Get to know how you process information. Next, explore how to access all the sensory modalities into the dance of each meeting or training you do.

Activities and games are one way to integrate all the avenues of information processing. You can structure bits of information in a game, make up mnemonics to remember a model, or color-code categories of data. Several years ago, I taught English as a second language to Russian immigrants. We sang songs to learn certain grammatical tenses; performed murder mystery skits, complete with stabbing and ketchup blood, to get across the concept of "would have"/"could have"/"should have"; and drew pictures on the wall to encourage people to tell stories. The more modalities you appeal to, the more likely it is that everyone will learn and remember, no matter what their learning style is.

How people process and retain information is frequently a mixture of visual, auditory, and kinesthetic senses. While one sense may predominate, I think that we all use all our senses. Our choice of words, metaphors, and communication medium can be focused to include all types of processing styles.

To appeal to visual thinkers, use handouts, posters, charts that you or the group creates, follow-up posters, and reports with visual anchors to keep the session alive long after it is over. Use language that visual thinkers respond to:

That's clear, or I see what you mean. What is your picture of success? What does success look like? Picture this. Make it brighter. Bring it into focus.

Notice how the person moves their eyes—visual thinkers tend to look up to access memory.

To help auditory-based people hear your message, you may want to use music to enhance learning or create a mood in the room. Studies have shown that people can better retain information, such as foreign languages, when listening to Bach. Use auditory language: I hear what you are saying, it sounds like, the tone of this conversation is…. That clicks for me, that rings true for me, it's clear as a bell. Auditory thinkers tend to look towards their ears—side to side—to access information.

To support kinesthetic thinkers, look for opportunities to have people move around the room. Ask them to vote with their feet for where they stand on a position or move to a location in the room to show what area of information interests them. Create a thumbs up or thumbs down, or stand up or sit down, signal for agreement and disagreement. Use language that expresses bodily sensation: I support that. How does that feel to you? What's your sense of that? Do you need time to digest that? That makes my spine tingle, I feel the hair on my arm stand up, I can embrace that. Kinesthetic thinkers tend to look down—to the body—to access answers and sometimes their thinking process is slower because they are going "inside" to get the answer.

These are just a minimal starter kit. Add to it!

Start with listening to yourself. What words do you use to express how you think and feel? These are clues for you to understand what modalities you favor. Make this an awareness game. Look over the expressions under each of the areas described. How do you record information—are you remembering pictures, colors, and scenes? Are you remembering body sensations, where you were standing or sitting? Do you recall the tone in a person's voice, music, street noise? We all use a combination of sensory information but tend to start with certain strengths. Knowing how you perceive will help you stretch your thinking preference and communicate with other people.

Next, watch other people—their eyes, their motions—and listen to their choice of words and metaphors and start to access their preferred mode. This is very valuable information in working with people and helping them learn, process, resolve conflict, and value differences.

Group Process Theory

In hundreds of meetings I've been in, there is a process—an energetic flow—to groups that I have come to recognize, and I want to share some of its tell-tale signs with you. Process is "how" a group meeting flows from start to finish, from beginning to end. You probably have many models that you already use for how groups function, stages that they go through, and the challenges and opportunities of each phase. What I want you to start to notice are some basic stages a group goes through so you can support them graphically.

In groups, and in yourself, the flow of process is like water moving in a river. It moves from wide to deep, expanding to contracting. A group can get caught spinning in eddies or use the eddy's momentum to flow back into the

mainstream of the discussion. In group process, we can move from closed to open, shifting from focused, detailed, and concentrated all the way through to wild, woolly spinning of ideas. Contraction, expansion, and distraction are three core elements. We need to find ways to recognize where a group is and how to shape information to support its process.

Let's look at some signs and indicators that can be clues to you about what stage a group might be in and where they are heading. Use them as starting points. As you work with groups, your experience will help you to recognize other clues and stages.

What does expansion look like? Ideas are bubbling all over the place, popping like popcorn, going in diverse directions, lots of issues—it's the territory before you arrive at any focus. Expansion can also have a focus, when many ideas are flowing for how to achieve a goal, strategy, or tactic. You can recognize the expansion because people are animated and passionate. Ideas are flowing and several people want to talk or are talking at once. The environment is charged and can be chaotic.

What does contraction look like? It is an intense drive to anchor ideas and make them tangible, a need to define outcomes, an emphatic desire to move forward out of generating and into "what can we really get done." There is a drive toward commitment and definition. People are wanting specifics: action plans, timelines, commitment of resources and people. Questions surface: What subcommittee will redraft the mission statement? When will the task team report back to the board? What is our message? There is less tolerance for additional input or wandering. You're usually running out of time—people want to go to lunch or make their flights. A concentrated intensity verges on uptightness and irritability; often the group feels rushed to reach closure. If you were seduced by expansion, then contraction can get put off until the final fifteen minutes of the meeting, but the group won't be satisfied unless it happens. Contraction is what makes the ideas generated in expansion come to life.

Contraction happens when a group or team needs to make a commitment to timelines, tasks, and responsibilities. Contraction feels more solid and tangible, like the earth, compared to the airiness of expansion. At times it is difficult, yet often establishing clear expectations, roles, and responsibilities is a relief. People want to leave a meeting with a plan and an understanding of who is going to take ownership and action.

What does distraction look like? You'll see yawning, leaving the room, side conversations, passing notes back and forth, low energy level, a hollow tone in people's voices. Every sentence seems to be a non sequitur, and no one seems to be listening or receiving the information. There is a big crowd at the coffee table. People take many bathroom breaks, even just after the official break. The group seems to have checked out, and you are doing the workshop or meeting by yourself. Does this sound familiar?

Not everyone will have the same orientation or be with the flow of the majority of the group. Sometimes, a group is expanding into the zone of new ideas, and one person needs to know more detail to be comfortable. Other times, there is tension when an individual continues being divergent while the group is seeking closure and commitment. Not everyone has to be or will be in the same place at the same time. There is a perfection in who is present in the room and what role they play in defining process. You are an integral part of this picture. Watch for your own orientation as an important ingredient—does the group need to go where you tend to go?

In group process, we are looking at a dynamic flow where a network of perspectives come together. These perspectives exist on continuums: personal/organizational, historical/futuristic, process orientation/product orientation, abstract/concrete, relational/business results. What other continuums can you add to this collection?

Go to a meeting where you can be an observer rather than a participant or facilitator. Draw a timeline of the meeting and track expansion, contraction, and distraction. Use a sheet with the top marked "Air" and the bottom marked "Earth" and sketch how the group moves between the two. Note where the group gets distracted, using spirals or whirlwinds in between the top and the bottom of the page.

Try this exercise using the river metaphor. Draw the river at different widths to indicate where the group expands and contracts. Use eddies to indicate distractions and rocks for obstacles. What else are you perceiving? Side forks in the river? Separate channels?

Was everyone on the same page throughout the meeting or did people shift back and forth between different orientations? Did any one individual dominate or try to steer the group to their orientation? Were discussions only about the content or were there discussions about process, such as how long to spend on one topic, the need to approach something in another way, or differences about voting processes? What did you want to do at each point, at the junctures, in the swamplands? This is valuable information for you about your orientation and preferences and where you may likely sway a group with your unique fixation.

Each of the graphic formats supports various stages of process. The display of information has an inherent power to focus a group to fulfill tasks of that stage of thinking. For example, if a group is expanding, capturing the brainstorm of ideas in a loose cluster map or

mindmap supports a wide-ranging and free-flowing discussion. This gives people a way to see all the ideas on one chart and then circle back around to identify relationships and patterns. When a group is contracting, lists and grids are useful to organize and focus responsibility and commitment. Dot voting and color-coding lists can help a group clarify what has been decided. When a group is distracted, draw a cartoon or change what you are doing. Maybe it is time for a stretch break!

Remember that the formats are like snapshots of a multidimensional moving picture. Make up your own combinations to reflect your thinking or a group's flow of discussion. Fluidity is essential because live group process calls for real-time responses. Keep your graphic options in mind, but be prepared to shift and go with where the group is heading. Improvisation is more useful than following your plan.

Looking at process will help you understand the role of graphics and your role in working with a group. You are capturing the content of a group's discussion and also the flow of ideas, oscillating between expansion and contraction, abstraction and detail.

As a graphic recorder, someone else is managing the process and you are creating a record, capturing the dynamic flow of group discussion. Stay in touch with the facilitator for clues on what they are sensing. Use eye contact, verbal and written updates to each other, or hand signals if you are across the room from each other. As you work together and get familiar with

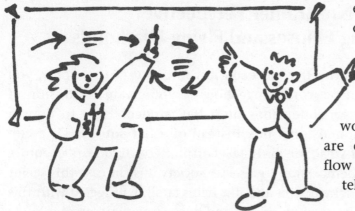

each other's style and orientation, a field of understanding grows where your perceptions can be synchronized. When this is working, it feels as if you are of one mind and the flow between you approaches telepathy.

If you are working with a group as a graphic facilitator, you are usually not getting involved at a content level. Primarily, you are managing the process by observing the flow of the group and assisting to keep them on track toward defined goals. What you sense about where the group is going and wants to go will affect how you depict each phase of a meeting. There may be times when you step out of the facilitator role and become a consultant—be clear about when you are doing this.

What you bring to a group is not only your understanding of process and your ability to capture essence and organize the display of information. You bring your ability to hold open the space, to listen compassionately, and to be present.

No-Brainer Perspective:
Using Ellipses and Flying Diamonds

Up until now, flat has been just fine. But at this point, you might be wondering—how do you create an illusion of three dimensions on a flat surface? How to draw a dimensional box instead of a flat square? Or a cup instead of a circle? Fortunately, it doesn't require membership in a secret society. Just in case this seems tricky to you and if it helps at all, I struggled with this too. It seems so simple and doesn't demand great manual dexterity—but it takes a shift in perception to "get it." The biggest shift is in seeing, in starting to perceive the stretched shapes. When I studied perspective with Jeff Leedy, I worked on this for months. He was very patient as I bumbled along. So please be patient with yourself as you open up your eyes and mind to see in a new way.

Here's how to get started with adding dimension to square and round objects.

Take a cup or a glass and hold it directly below your face. As you look down on it, you see the circular shape of the cup as a perfect circle. As you move the cup up toward eye level, notice the shape on the inside of the cup. It becomes more and more elliptical. Now experiment with a square object—looking down on it, it is a square shape. Moving it upward, to eye level, the top surface looks more stretched like a diamond.

These shapes—the ellipse and stretched diamond—provide a starting place for drawing any round or square object. And as it turns out, there are quite a few.

Start with looking. Be patient here—you are shifting your inner vision. You have to replace a Memorex tape that says: "It's a square object, so I'll start

with a square." Instead, now when you see a square object, look for the stretched diamond. When you see a round object, look for the ellipse. The mind is persistent, and it may take some time to see the shapes. If you don't see the shape, imagine that you do—fake it until you start to see it.

EXERCISE:

To start, practice these shapes so that they are effortless. You can trace over the samples until you are satisfied with what you are sketching. To get the shape stretched enough, you may need to draw a few hundred. Well, maybe you won't have to, but I did. Whatever you are drawing, I bet you can stretch it more. As if it were Silly Putty, stretch it horizontally... even more...streeeeeeetch.

The most common problem is that the shapes are too wide to convey the illusion of two dimensions. For the ellipse, the second most common misunderstanding is to flatten the bottom line. Actually, you need to exaggerate the curve on the bottom line of an object and connect the side lines at the peak of where the ellipse curves.

For all round objects, it actually helps to think about the roundness as you are drawing and send the lines curving back

around the imaginary back of your shape. Here's another place where caring about the lines really shows up in your final product. The lines are sensitive and respond to caring, what can I say?!

For square objects, keep the vertical lines on the vertical, not slanting off in a random direction. The parallel relationships of all lines creates an overall visual message that spells box. When some of these lines are askew, it spells confusion and the eye doesn't quite recognize it as a solid box.

Recreate the stretched diamond and ellipse until it is as thought-free as your writing. As you are doing this, play with building shapes of diamonds and ellipses in both directions—above and below. Turn the ellipse and diamond on their sides and see what you come up with: lights, an accordion, angles of perspective. Use the examples here to get you started, but also look around your house, office, or other environment, and find more round and square objects to practice with. You will soon have an easier time with the images in Toolkit 2 and more ideas for enhancing what you've already learned in Toolkit 1.

Look at all the shapes that are created from the diamond.

More detail on boxes: Draw the stretched diamond, then drop the longest line in front. The lines on either side are a little shorter and about the same as each other. Connect with parallel lines.

Wow, the ellipse has all kinds of possibilities!

How about adding a cover to the ellipse and playing with shapes to depict hats, teapots, umbrellas, and spaceships?

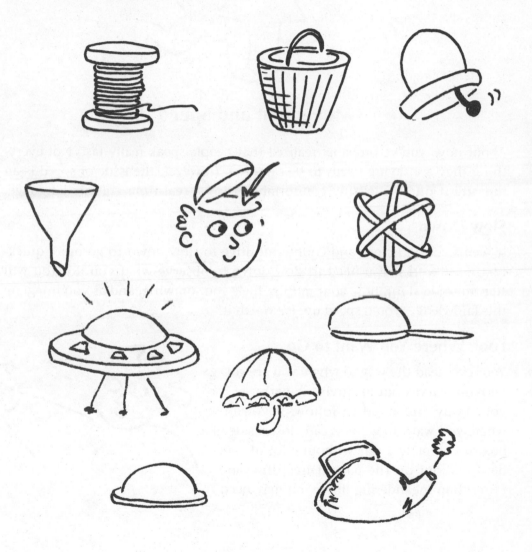

Movement and Speed

About now, you've probably realized that people speak really fast. Not everything they are saying needs to be captured. However, the issue of speed is an important one for getting comfortable using a real-time graphic language.

Slow Down

It seems contradictory and counterintuitive to slow down to go more quickly—but it works. You need to slow down to observe what you do. You will start to understand how your motion fuels your drawing, and as you integrate this knowledge, you'll speed up. It's worth it!

Look Where You Want to Go

Your eyes lead the way to where you are going. Looking carves out an invisible pathway for your body and hand to follow. If you look where you want to go, you can close a side of a box or complete a star without a lot of wandering about on the page. Direct lines are faster than meandering lines. You may need

to slow down to observe this phenomenon. Once you do, you will find it yields a lot of speed and freedom from conscious effort.

Getting Out of Your Own Way

You've seen that your body already has an innate under-standing of height, width, diagonals, circles, and spiral motion. When you allow this body knowledge to be the source of your drawing, you will find a dynamic source of energy and speed to fuel your drawing. Spend some time exploring the body source and initiation for strokes of all sizes. While we have explored this in lettering and large strokes, examine your motion while drawing each icon.

Let your inner awareness rove around to different parts of the body. Each area of the body is a teacher. Sense your core strength flowing along your spine, gathering in your belly. Notice how your waist determines your ease of turning and is the center for controlling side-to-side twisting. Your ankles, knees, and hips are treasure houses of flexibility. Even gently swinging from side to side and front-to-back pulsing will help you contact an energetic flow in your body that will help you stay tuned to yourself and to the dynamics of a group.

Using Gravity

I know, it seems obvious—things move faster going with gravity than against it. That's true of large strokes and it's true of the direction of strokes within any image or let-ter. SO—check out the order in which you are creating graphics. Most likely, you'll find that anywhere you are struggling, wobbling, getting results you are not happy with, you're going against gravity.

Go in the Direction You Are Most Comfortable With

This is a similar principle to gravitational pull. If you are right-handed, you will be most comfortable moving from left to right. If you are left-handed, or would have been left-handed if you had been allowed to be, you may be more comfortable moving from right to left. However, your early conditioning may interfere with this flow, so please experiment. Find out which direction you are most comfortable with and then apply that information to the direction in which you draw all lines of images and letters.

EXERCISE:

Pick an image you are working on that you would like to improve. First, draw it large! Then take it apart and check: Are you making each stroke with gravity? Do you make your strokes in the direction that is most comfortable for you? Are you rushing? Come on, you can slow down. Find the source of the motion from your own physical impulse—maybe a waist turn or bending the knees—but don't abandon your arm to create all by itself. Now, look to the point where you are heading and sense your eyes pulling, leading the way. As you put this all together, you are finding an integration within each image or letter that will yield more grace, fluidity, and speed.

Good work! Keep it up!

Presence, Part Two: Taking Care of Yourself

The role of a graphic recorder or facilitator is similar to a language translator. A high degree of focused attention is required to keep a clear mind, stay in the present, extract the essence from dialogue, and create spontaneous visuals. You are working with finely tuned attention and need to take care of yourself as you would take care of a musical instrument. Taking care of your physical needs is one way to help your performance as a graphic translator.

Here is a beginning mindmap of issues for you to add to and personalize.

Food

- Healthy snacks.
- Bring your own food, depending on the meeting.
- Watch out for caffeine highs and sugar blues.
- Be sure to eat, especially if you are working during lunch and breaks.
- Drink plenty of water.

Comfort

- Are all your materials in order (markers, razor, tape, pastels, paper cut and hung)?
- Wear comfy shoes and clothing.

- Is the height you are working at suitable for your height?
- Monitor the temperature of the room.
- Is there sufficient lighting?
- Have a chair nearby in which to rest.

Breaks

- Take them.
- Get outside.
- Breathe.
- Move your body.

Centering

- Use your personal checklist.
- Breathe into your belly.
- Relax your jaw.
- Give yourself a mini neck massage.
- Are your knees soft and relaxed?
- Shake and circle your arms to let go of tension.

In addition to caring for physical needs, let's examine taking care of the instrument of your awareness. For many people, a very old habit is to abandon inner awareness when you open your eyes. The eyes are gateways for giving and receiving, and very often when they are open, we are focused only externally. Use this exercise to experiment with having an internal focus while your eyes are open. This can help you stay in touch with your intuition, emotions, inner vision, and inner voice while still interacting in public. Staying connected with yourself while being in a group means you bring in the spaciousness of true presence. Being fully present in this way will facilitate group interaction even if you never pick up the pen.

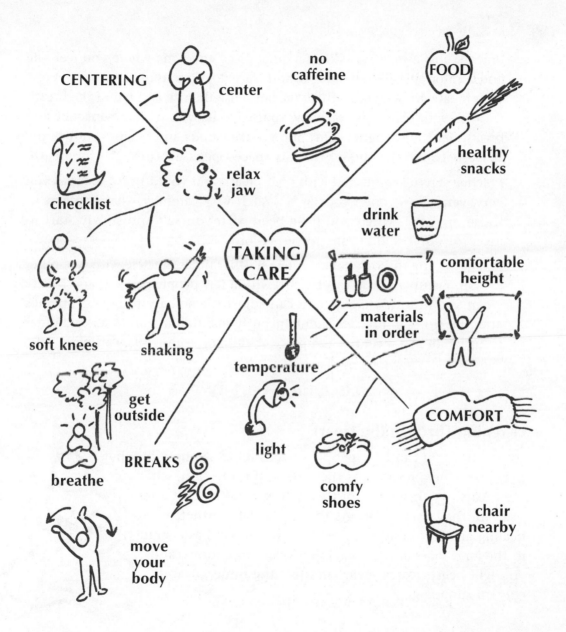

CENTERING

center

no caffeine

FOOD

healthy snacks

checklist

relax jaw

TAKING CARE

drink water

comfortable height

soft knees

shaking

materials in order

get outside

temperature

COMFORT

breathe

BREAKS

light

comfy shoes

chair nearby

move your body

Practice this awareness skill in a quiet place and time where you feel safe and comfortable. Close your eyes and place your hands on your belly. Allow your breath to deepen, so that you can sense the rise and fall of the breath through your hands. As you allow yourself to be with your present state and breath, let the thoughts come and go like clouds and begin to notice the space between the thoughts. This space opens up through the breath.

Practice staying connected with your breath and your inward focus as you very, very slowly open your eyes. Watch very carefully what happens in those moments when you have been with yourself and slowly start to meet the outer world through your vision.

Practice doing this by yourself, then at other times practice with one other person. Eventually you can try this with a few people present, and finally when you're with a group. You can adjust the activity to be less obvious and find times to practice simultaneously maintaining an inner and outer focus while in a meeting, at a party or club, or even while waiting in line.

Listening, Part Two

Listening Through the Heart

Sometimes you can hear people's needs more strongly in what they are not expressing. As they speak of protection, what are their fears? As they speak of themselves, what kind of attention are they asking for? As they speak of conflict, what healing are they desiring? View the spoken word as a strata in the land mass of needs, emotions, and intentions, and you will begin to see, hear, and feel the underground content surfacing.

This also proves helpful when you have strong opinions of a speaker's content. You may not agree with the content, but you can still listen for and seek to understand the motivation and perspective. In fact, this is essential or your disagreement may actually prevent you from hearing what the other person is saying.

Listening with Your Gut

Your body has information. The body is created of and informed by sensory information. Sensations in the body are a profound source of listening. When someone is speaking, listen with your gut. Listen for truth, clarity, honesty, and integrity. Listen for the absence of these, when you get a "creepy" feeling. Your gut will know—it is your bullshit detector.

Listening Without Judgment

Can you be the open receiver and hear everything without getting hooked into your own judgment, offerings of advice, or opinion? It is a challenge to be open to listening and even a greater challenge when you disagree. In this case, get curious about how the human mind works, even when you don't agree with the content. Get curious about why this person particularly pushes your buttons. This absolutely relates to listening with your heart and seeking to understand the person's perspective.

Listening With Judgment

Okay, so you are human. Can you have the judgment and still listen with an open heart? You don't need to dissect the person, his or her intellect, manner of expression, speed or slowness, need to control, egotism or lack of it—and if all that's there, accept that too and keep listening deeper. Accept your own judging. You know you are hooked, now find out what else is going on.

Usually when I am hooked into judging, it's because that person is a mirror for some wound in myself that is not healed yet. Or the person represents,

speaks from, reminds me of some part of myself that I have not accepted. Of course, in that moment, that's the last thing I want to admit. But if this was not so, why would it be such a big deal for me? If I had accepted myself, then I could also see the other person with compassion. If you accept your own judgment, at least you are stopping the loop of judging yourself for judging...which is a downward spiral into infinity. It's an important moment to witness.

EXERCISE:

As you listen, notice what is coming up for you inside—it may be thoughts, sensations, analysis.

Take each of the awarenesses mentioned here, one at a time, and practice listening, tuned in to that channel. You can practice any of these at work, at home, as you listen to the news or to other people's conversations.

Banishing the Critic, Part Two

The inner critic is the main obstacle to free-flowing creativity and improvisation with whatever you do. The critic can be obvious and also subtle; it can move you into immobility or simply make you miserable. Either way, it will limit your flow and enjoyment of experimenting. When you are in the midst of a self-critic attack, it can also interfere with your ability to see clearly, track comments, and hear patterns.

How to recognize the signs and symptoms:

- Your drawings get smaller or disappear altogether.

- You only record words and they get smaller too.

- You start crossing things out or wanting to.

- You hear an internal critical commentary.

- You leave the moment, leave a sense of gentle acceptance of yourself and of the group. (For interaction with the critic and the group, see Banishing the Critic, Part Three)

Here are a few ideas for responding to the critic in the immediate moment—here and now. Then we will take a look at responding to the critic in past and future time.

Banishing the Critic

Talking back to your inner critic takes some practice and it's well worth your effort! The test of effectiveness is that the inner critical voice is silenced. If you find yourself involved in an internal battle with the critic, then you have engaged the critic, not silenced it. Tone and conviction make a huge difference.

Here are a few anti-critic comments to get you started:

- What do you know?
- That's silly.
- You're full of it.
- Wrong address.
- I'm busy, we'll discuss this later.
- Go send me a report.
- That's boring.
- I'll consider your view and we'll discuss it in a month.

Add your own and practice, practice, practice. I bet you have plenty of opportunity.

Suspend the Inner Discussion

Keep drawing and don't get involved in reacting to the critical attacks. Put that marker on the paper and keep it moving. Stay with this present moment.

Let in people's acknowledgment and allow it to dispel any negative voices from the past. Letting in compliments and acknowledgment is a challenge when the inner voice is loud. In the long term, you can choose your experience. When someone is telling you that what you are creating is working—it is! You can choose to listen to that or listen to your own critical attack.... Hmmm, let's see, which one shall I pick?

Be Gentle

The attack will continue until it doesn't. Confronting or not listening to the critic is disrupting the ego architecture and this is a major piece of self-work. Be gentle with yourself—holding yourself with emotional compassion as you would hold a small child. This contradicts the harshness of the critic.

Dispel the Ghosts

They are not here in the room—you are! You are bringing your insight, style, ability, and improvisation to the session and because this is so, this is what is needed. If you are in such a situation, it means you were courageous enough to get there! Now be as fully involved as you can be!

Breathing Helps

If you are following in the footsteps of someone else's work, remember that you each have different strengths and qualities. I've followed people and it's a challenge, because each of us has a unique style, personality, and way of working. My drawings tend to be big, loose, and expressive. I usually capture as few words as possible to get a point across. When I have followed someone who does more precise drawings and captures more words, I have to remind myself to breathe, accept, and honor the value of each mode of perceiving.

Ask for Help!

Just do it—you can involve people in the process all the way through. Before, during, and after, from hanging paper to pacing to feedback and rolling up charts—ask for support! If you try to do everything alone, it's too much and you won't be satisfied with your results. So ask for help and have some fun, instead of giving yourself such a hard time. And remember, the tools you are learning here nurture an open, mutually supportive interaction. Asking for help is part of it.

Basic Concepts, Part Two

It's time to add to your toolkit. These images depict concepts that are frequently addressed in business meetings, trainings, and presentations. They are versatile vocabulary units and will help you depict time, quality, money, resources, out-of-the-box thinking, and more. As you practice drawing these images, brainstorm additional meanings that they could be used for. This will help you expand your applications of the same toolkit.

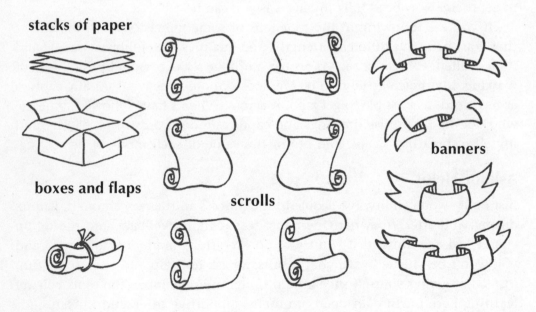

stacks of paper

boxes and flaps

scrolls

banners

Seek to gain an ease with drawing these images. Your goal is to have these flow out of you as fluidly and thoughtlessly as your signature. And indeed, these graphics are your graphic signature. Make them your own. These pictures are starting places, not places to stay stuck in. If you have or discover another way to depict these concepts, please use that! Think of the images drawn here as catalysts to your own creativity, imagination, and style.

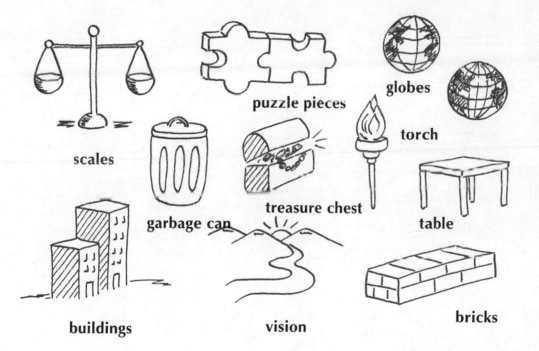

scales

puzzle pieces

globes

torch

garbage can

treasure chest

table

buildings

vision

bricks

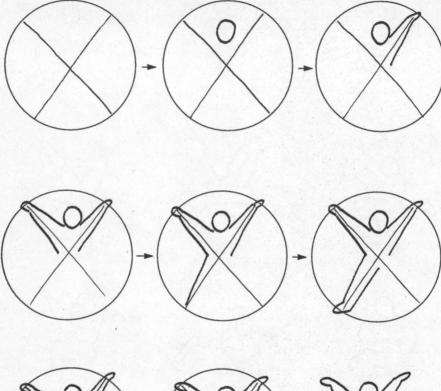

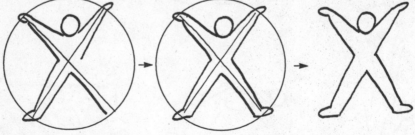

Organization, Part Two:
More Complex Ways to Structure Information

Let's take a look at other ways to organize information. Remember that these are snapshots and there is fluidity among these formats. Basic organizations can be integrated within the more complex ones. These structures can be mixed and matched to serve the situation.

We could just as easily slice this out by processes:

- Brainstorming or a mind dump: lists, clusters, mindmaps
- Brainstorming or seeing relationships: clusters, mindmaps
- Organizing and committing: grids and lists
- Loosely organized: simple frames, maps
- Integrating the big picture (loosely organized): drawings—maps, landscapes, metaphors
- Integrating the big picture (more refined organization): mandalas

Branching and Diagrams

Branching relationships can take off in every direction: vertical, horizontal, and radial. Because branching does not have limits, this structure supports fast-paced discussion, brainstorming, searching for causes and solutions. It is easy to show relationships between branches as well as multiple levels of detail in the offshoots. Look to nature for examples of this structure: the shape of tree branches, leaf patterns, flowers, fish bones, and neurons.

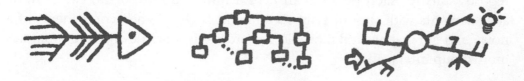

Watch out: The strength of branching to accommodate detail can also be a weakness. Every type of diagram can get unwieldy, very detailed, and hard to read. The angles of the offshoots add to the illegibility, so when you are working with a group, adjust your writing to be on the horizontal, not diagonal or upside down.

EXERCISE:

Take your sketchbook or journal and go for a walk in the library of nature. Either take photos with your mind's eye or draw sketches of the patterns in nature. Look at trees, bushes, shrubs, and flowers for examples of branching. Some of the configurations are so intricate—the stems branch off a core, and then each stem has smaller ones off it, and off of these are even more delicate branching leaves or cones that carry the same repeating pattern. Your sketches may give you ideas for how to organize information for your next training or presentation.

Horizontal branching is seen in fishbone diagrams where people map out elements contributing to a goal or a problem. This often breaks down into categories of money, management, methods, and materials. Vertical combined with horizontal branching is seen in organizational charts and flow charts. Mapping out organization charts is valuable in depicting and reporting relationships and spotting potential overlaps and conflicts.

Flow charts provide the fluidity to look at complex processes and pick them apart. Flow charts can be made more graphic by using symbols to identify repeating events: circles for meetings, diamonds for decisions, squares for reports, stars for successes, and arrows for flow and movement. Create movable elements with cut-out symbols and Post-it glue. When components of a flow chart are graphic and movable, the process is more flexible and promotes more group interaction.

You may already be familiar with mindmapping, where information branches out radially from a central theme. The good news about mindmapping is that information is organized the way the mind moves naturally. There is no correct number of branches or subbranches. You can integrate graphics, symbols, color, and words. The beauty of this form is that you can bounce from overview to detail, from one topic to the other. This flexibility makes it easy to keep up with a stream of consciousness or the flow of discussion in a group. Notice how mindmaps are like the maturation of the clustering form.

EXERCISE:

Create a mindmap for yourself around a personal or professional issue that is current for you. It could be anything from how to not eat cookies during trainings to getting a project off the ground or planning a staff meeting. Do a first rush of ideas and then go back and add any detail that seems necessary. If you have a lot of detail in one branch, start a new mindmap with that topic in the center. Next, go back through and identify the top priority branches and the top priorities within the primary branch. It's getting serious. Identify action steps with dates on at least your first two steps. Post the mindmap so you can keep track of your progress.

Make a mindmap of all the places to use a mindmap! Sales calls, study guides, meeting notes, speech preparation, prewriting a report, planning anything—a meeting, wedding, party, program, or course. A mindmap is a great and versatile brainstorming and planning tool.

Use a mindmap in your next meeting for brainstorming and identifying elements of an issue. Remember to reserve one or two colors for highlighting connections at the end. Add graphics around the main topics and where you have ideas for the subbranches. The mind remembers graphic

sandwiches—pictures encapsulating words—so give the mind something to chew on.

Drawings

This includes maps, landscapes, metaphor drawings, and combinations that you will invent for depicting complex information in a lively way. At this point, you are cooking with all colors, use of space, integration of lists, clusters, and diagrams, all within a larger organizing frame. These nonlinear depictions open up thinking about a project or a situation.

Maps Are a Nonlinear Concept When you want to know where you are going, you get out a map...and it turns out to be a good idea! An outline of a state, country, continent, or globe focuses and grounds a discussion by creating a common background. Even if only an outline is indicated, this form says that we know where we are going. It visually gives ground and substance to more abstract discussions.

These more complex forms make them well suited for discussions on multidimensional issues. Identifying trends, marketing strategies, strategic planning, strategic visioning, and depicting skill sets are all useful sites for mapping.

Nongeographical frames are also useful, such as the outline of a human being to organize information about a skill set or geometrical shapes to depict a model. This form integrates lists, clusters, grids, and branching in any combination, depending on the content.

EXERCISE:

Create a map for yourself depicting the skills you are learning with graphic language or in another topic you are taking or teaching. Draw the out-

line of a body and then map information around the body in a way that works intuitively for you—things you are thinking about in thought bubbles around the head, groundwork on the ground, feelings around the heart, focus connected to the eyes, and so forth. As you start doing this, you will get more ideas and make new connections.

In a group, experiment with a very simple map framework, with current reality in a square, a goal in a circle, and strategies for getting from here to there in an arrow. Keep this framework in your mind, but don't draw it in yet. Start capturing information with lists, clusters, and mindmapping to organize the page as you go, without drawing the larger graphic frames in. After you are finished, add in the square, arrow, and circle frames—so that you are not cramped in your creation.

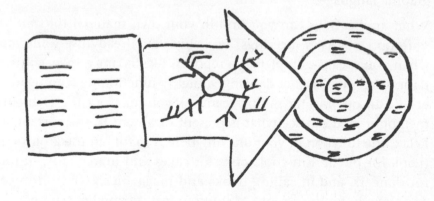

Metaphors Metaphors are nonlinear and may include a radial element. The group may arrive at a metaphor that is accurate for the topic being discussed, such as a vehicle for a project, the engineering of a bridge for connections, or a house for the architecture of a program. The important thing here is not a precise drawing but the accuracy and applicability of the metaphor to the actual content. Once the group tunes into a metaphor, it takes on a life of its own. Without consciously filtering, the group may not even bring up things that don't fit the metaphor.

Warning: Once you are working within a metaphor, it is easy to keep stretching so that you may force-fit reality to match neatly with the metaphor.

EXERCISE:

A great way to anchor information is to connect it with a memorable metaphor or analogy. What's a metaphor that works for you in learning this graphic language? Pick a sport or activity that you love to do and feel whole, happy, and confident doing. Draw a picture of yourself doing it and then pick out the elements of that metaphor and start to make a bridge to how you can experience the same satisfaction when using the graphic language.

What applications can you find in your own material for trainings, presentations, or sales meetings? Probably you already use some metaphors when you speak—completing a report is like baking a cake, contract negotiations are like partner dancing, a highly functioning team works together like an open-water sailing team. As you map out the elements of the metaphor, you can see what is present or absent in the current situation. Relax, the function of your drawing here is to fill out the group's thinking. (Look for pictures in cookbooks for cakes and ingredients, in magazines for dancers, and in sailing books and magazines.) Give a hint of image and then go for the essence of communication and lighten up!

Landscapes Are Nonlinear and Nonradial This is related to mapping and also has the inherent metaphor of a landscape, which everyone is familiar with. You can use a horizontal line to indicate the horizon and then capture information using placement on the page to help organize as you go. For example, below the line place unspoken issues, history, rumors (the underground stuff). Above the line, put vision, values, potential, things outside of your control such as media, legislation, market trends (blue-sky thinking, what's "in the air"). On and around the line is current reality—customers, competitors, current market conditions, internal and external environment (what's on the horizon).

The landscape can also be more elaborate and more metaphorical, relating to a journey through space and time on a road, in outer space, on a river. Signposts along the way may indicate time or important milestones in a strategic visioning map. Obstacles along the way can be depicted as road-blocks, and support could be support vehicles or help in the form of

parachutes or angels. These are starting places with no limits—just like your imagination.

You may also want to combine a landscape with a grid to take a look at how certain key result areas evolve over time. One way to do this is to identify key result areas along the left side of the page and draw the road heading to the vision on the right. Capture information inside of icons you've created for keys all across the map. It helps to start with the future first, and then work backward to identify milestones that will happen along the way.

I have used this format with individuals, groups of 10 to 30, and groups of 200 for strategic visioning sessions. The key result areas on the left need to be identified by the group. The key helps remind the group to deal with initiatives and milestones in all areas. For example, it's easy to see that something is missing if there is nothing along the communication band. Many groups stretch way out to the future and then bounce back to imminent, detailed tactical ideas. Work to get as many ideas as possible out in the future to help pull the group out of present-time crisis. Often the middle zone, say three to five years away, is harder to grasp. So I tend to condense this middle part of the chart and leave more space for the immediate future and the distant future.

Be prepared for a lot of group discussion about the validity of milestones and agreement on their placement along the timeline. This is an important discussion, because the group needs to negotiate an appropriate tension between idealistic stretch and pragmatic realism. What this means for you is to

wait. Do not capture ideas right away because the discussion and movement of milestones along the timeline is critical to achieving buy-in to the final vision.

One way to deal with tracking a lively strategic visioning discussion is to add the flexibility of movable icons. Prepare icons for yourself in advance, either on Post-it notes or icons or shapes with Post-it glue on the back. Prior to your meeting, draw the icons in black for each of the key result areas, leaving enough space to write inside each icon (at least four by six inches). Photocopy these on different colored sheets of heavy (card stock) paper and then cut the shapes out. Preglue the shapes lightly onto regular copy paper and store each type of icon in plastic bags. At the meeting, you may need to add some glue, so enlist a helper to assist in icon handling.

EXERCISE:

Practice creating a landscape for a self-visioning map—you can create a vision map for yourself or use the one in the book. To contact your "future self," imagine a time in the future when you are feeling completely comfortable using graphic language spontaneously with groups. What does that feel like, what are you seeing, what are you hearing? Anchor the sensation of success to all of your senses. Then start to look around you—what wonderful feedback are people giving you, what is the powerful impact of charts you've created? Now look back and see what were your biggest breakthroughs. Who gave you support, encouragement, and opportunities? What were your experiences along the way? What places did you use graphics in? What types of meetings and environments did you learn in? What were the action steps you took to achieve this success? If you had some words of wisdom to tell your beginning self, what are they? Your future self exists and is waiting for you to join forces. This works for graphic language skills, but where else would you like to activate this visioning practice?

Work with a small group to create a landscape with the basic horizontal line to start. Draw the line about a third of the way up the page. Discuss issues relating to the work environment with the group, department, or team. Place issues "geographically," with the concrete realities on the

ground and problems or history that are submerged underground. Above the ground may be trends, changes, things out of your control, such as media, public image, or legislation. Place overarching principles in the sky, with future hopes and dreams even higher. Include people, competition, environment, and communication issues on and around the ground.

As the discussion unfolds, the group will start to make connections with the areas of information. One of the beauties of landscapes is that the distribution of information offers a lot of insight into where the hot spots are. Be sure to stay true to participants' words and ask the group for help with placement, repetition, and connections. If you are dealing with very technical information or material that is unfamiliar to you, have a group member stand with you to help with acronyms and clarification.

Mandalas This circular organization of information helps show an overview and integration. Remember from our look at circles that the circle has a synthesizing and harmonious aspect that comes across through the mandala. It is as if a stone were thrown into a pool and concentric circles depict the emanating ripples. The form pulls you into a higher level of thinking in systems and seeing the whole picture as if you were standing on a mountain and looking down.

Start at the center with a central theme. Radiate out in concentric rings of information—these may be visible or invisible. You don't have to write upside down, just place your writing around the circle and keep it legible and oriented just as it would be on a vertical list.

Mandalas are good for showing integration. For example, put skills in the center circle and then show how to practice and apply each skill set. Mission, vision, values, and goals displayed in a mandala will convey more integration than if they are written out separately. A variation can be used to map out who is present at a meeting and what goals or questions each person has.

Create a mandala for yourself with the core graphic language skills in the middle, how you can apply them in the next circle, and ideas for practice in the next circle. Take your time with this, as this is a different way of mapping. The beauty of this structure is that it is very integrating and easy to see if some area is out of balance.

An easy place to start doing mandalas in groups is during introductions. For example, state names, goals, and a little-known fact about each participant to break the ice and also give you a chance to capture the information in a design that is inherently inclusive and unifying.

Also use a mandala to show how the mission, vision, or values expand throughout an organization. For example, place the mission in the center, and then in radiating circles, show how it guides the department, team, and individual. This is highly flexible, so experiment with your own categories organized in this radial format.

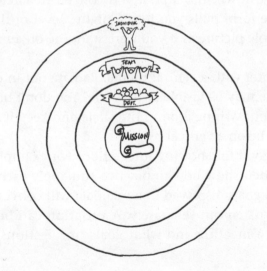

Toolkit Three

Wow, It's Mine!

• Toolkit Three •

Wow! You have come a long way since you first opened up this book. Now that you've gotten so much farther, you can cruise through Toolkit 3. Look for and specifically nurture your personal style of depicting ideas. Strengthen the links between concepts and images you use frequently, so that you are more prepared to respond in real time. Expand your comfort zone by understanding how you tick when using a graphic language live, with groups.

Create your own characters, your special images, your unique way to promote communication. Find ways to bring life to your trainings, teachings, presentations, and meetings. Find ways to clarify thinking one-on-one, in groups or teams, professionally and personally.

How you work will be growing and evolving in your own unique way—make room for it. Take plenty of time and space to explore your personal relationship to creativity, to develop new images, new ways to organize a page, and new ways to support your work with groups.

Throughout this book, you have been practicing a lot and experimenting with applications of each element of a graphic language. It's not over yet if you want to continue growing your skill and to increase your ease and comfort. A practice plan that you create and follow is critical to your ongoing success!

Personalizing

How you draw is unique. When you capture the essence of what is being said, it is filtered through you. It is filtered through how you are feeling in that moment, what you heard, what you are comfortable with. You show up on the page—in the quality of your strokes, your comfort level, your use of space and color. It is essential to respect your own process of learning and appreciate every phase you go through. It is also essential to respect your style and not try to manipulate yourself to create drawings that look like someone else's or the ones in this book. Your signature is unique, the way you dress, express yourself, think, live, move, and draw—UNIQUE.

As you change and grow, your drawing changes. Your confidence grows and gradually or suddenly, you draw with even more boldness, more oomph, more connectedness to your movement. It is wonderful to keep samples of your work so you can trace your evolution as you continue learning, growing, and transforming your drawings.

As you create images, some very personal trademarks will emerge. I can't predict what they will be, but they emerge from your experiments and explorations. It may be how you make a banner or that your faces bear some resemblance to you or that you have a favorite squiggle. Be on the lookout. Encourage every wiggle and squiggle that shows up!

Get inspired by the styles of different cartoonists and graphic artists. Flip through magazines for cartoon ideas; take a walk through a card store and take notes and sketches. Sometimes, it's fun to trace over junk mail designs and graphics in magazines or newsletters. Then as you trace, let yourself go into doodling. Watch how your doodling shifts the emphasis, adds character, a different feeling tone. Next, start the same image but do it without tracing. Create your own style, add your own embellishments and your version of perspective and animation.

Another time, experiment with different media—crayons, brushes, colored pencils, ink or felt pens, mechanical pencils. Each media will bring forth a variation in how you depict images. While you may not use these materials when you are working with groups, you will open up a new territory in yourself that will come across when you are working with markers.

I realize that I might be the catalyst for your growing desire for pens and art supplies. But I think there are worse obsessions and this one will give you a lot of pleasure and hours of exploration and creativity.

Movement and Energy with Groups

Your movement communicates messages to the group. Flow in your physical movement helps the flow of ideas. It's also the key for you to keep up with the speed of a brainstorm. Your speed is a message to the group that they can keep ideas coming, not have to slow down to help you. Instead of being a bottleneck stopping ideas from flowing, you are the clear water that carries ideas as fast as they can come forth.

Work Big

Use big paper and big motions whenever you can because

- Large motions yield large sketches that everyone can see.
- Larger graphics, lines, circles, and arrows express big emotion, importance, or urgency.
- Working large conveys permission to look at the big picture, the overview, and not get stuck in the details.
- Large graphics and titles can encapsulate smaller ones.

Do I like working large or what?! Press the magnification button on whatever you are doing. Your motion and energy are fuel for thought and provide momentum to the group for breaking through barriers, obstacles, and stuck places.

Initially, I was not conscious of the impact of how I moved, but many participants gave me feedback that it positively affected the group. I started being more aware of how I was moving and noticing opportunities to influence the energy in the room through how I moved in the creation of charts. You're ready to notice this. You do not have lots to do; it's another place to observe, experiment, and start playing.

Change Levels

When you change levels, you send a message that you can use the full spectrum of resources. You model an ease with using all perspectives.

Alternating levels is something to get comfortable doing—standing, lunging, bending with your knees. You also may want to add ladders, step stools, or stages to work at a higher height so that a large group can see you.

It is amazing how many meeting rooms, hotels, and conference centers don't have uninterrupted wall space. They have sconces, paintings, columns, molding, mirrors, bookcases, bumps, and protrusions. So you may need to hang paper vertically between molding and ask the maintenance department for ladders. You might need to practice your skills with a razor and cut out a shape to fit paper around a sconce. You may need to create a wall with foam board to establish a smooth surface. I've encountered all of these situations and I've walked into too many rooms where there isn't a usable wall. It's a good idea to check out the room in advance and plan how you will create a wall and some light on it.

Use the Whole Space

Create different "fronts" of the room. Using different areas of the room can help keep the energy of a group moving and also may serve as a metaphor for the group you are working with. For example, in one meeting of a proposed alliance between two organizations, each organization worked on different sides of the room, each with a graphic recorder to create a chart, and then joined together and worked in the middle of the room as we crafted a map together.

EXERCISE:

Where can you apply each of these ideas in your next meeting, training, or presentation? What else can you do to use the whole space of a room? Think of your movement as an energizer—how else can you move, stand, or trigger movement for the group to bring in this element?

Presence and Sustaining Yourself

Working with groups is a fascinating balance between activity and receptivity. Here is a place to practice and apply everything you have been working on. Listening, sensing, drawing, breathing, using the whole space…and developing your receiving skills. When you are more relaxed, you will hear differently, have energy throughout the day, and bring more to the group.

When I first starting doing this work and for several years, I'd get incredibly uptight about hanging the paper. I'd wrinkle the paper, cut it unevenly, step on it, and hang it crookedly. I'd feel rushed but forget to ask for help.

By the time I finished that ordeal, I was flushed, sweating, angry, and questioning why I did this work at all. I was ready to leave before I even began the meeting. Not a great state in which to start a meeting.

As time went on, I slowed down and figured out how to get more satisfying results. I asked for help. I brought precut paper with me. I allowed more time. And when I was finished with the preparations, I'd go outside or at least walk around the room and calm myself. I'd create a moment of space to complete my material preparations and ready myself to begin. It may be something else that triggers you, but calming yourself will help you enjoy your time and be more available for what is about to take place.

Here are some ways to help you calm your body and mind while in sessions. Having done that, you are freed to notice and perceive what else you're doing in your role as graphic translator. This first came up for me during a session with a group of trainers where we did a visualization to examine how we each thought of the essence of our work. During those few moments inside, I saw a tall, wide, golden bridge and heard my inner voice say, "I am a bridge." This stayed with me and the meaning continues to unfold as I explore being a bridge of space, of images, of meaning. You will find your own images to guide you and help you express what this work is for you.

Your ability to stay in the present creates the space that is a bridge between words and images, between images from the group and what you capture on the paper, between what has been said and what will be said. As a translator, you are poised, actively waiting and also flexible in taking action. During discussion, you may be holding several comments in your mind, waiting for essence to emerge. While you wait for a group to synthesize or coalesce an agreement, you are perched and poised for action. This requires a huge degree of detachment and respect for how the group needs to flow.

The more you can be a clear translator, the more you'll support the group.

EXERCISE:

Before you start a session, gently remember what works for you to stay in contact with your presence and breath. Experiment with imagining your awareness expanding as if you are a container wide and deep enough to

hold the entire room. Imagine embracing the space, as the sky embraces the world. Physically experiment with keeping your eyes in "soft focus," looking wide by using your peripheral vision and not grabbing for details with your eyes. This helps support a welcoming and receptive state.

Now notice the ground and how the earth supports you. Sense that support and strength in your legs, pelvis, and back. Remembering feelings of flow and flexibility in your legs helps you inhabit the earth dimension. Envision roots through your feet and sense that you can draw in nurturance and earth energy (even if you are in a concrete-block building on the twenty-fifth floor). This earth supports you, supports the room and all the people in it. You are the connection between sky and earth, the translator who takes ideas into tangible pictures and words.

Draw a sketch for yourself of what your connection looks like to the earth, no matter where you are. What is it made out of? What does it feel like? If you want to strengthen that connection, imagine that you make the picture brighter and bigger. If there are sounds, make them louder. Sensations, make them stronger. You have access to the control panel that regulates this image and your sensations of connection. Take time now to strengthen your connection with earth.

Draw a sketch of how you perceive supporting the group. How do you perceive holding the space: a container, channel, transmitter, bridge, or conduit? What sensations or messages do you experience that will help you hold the space for the creation and synthesis of ideas? The image may change in different situations, but this is a deep, inner experience of yourself. Just as you can strengthen your connection with your breath and with the earth, you can cultivate a deeper connection with the place where you are both receptive and active.

Listening, Part Three

Listening for Patterns of Processing

Every group is a collection of individuals with unique orientations. Within groups, there is often a tone quality that is specific to that organization, corporation, or nonprofit. One person may be very visionary (A), another very bottom-line (B), a third repeatedly returning to unfinished business in the past (C). In a group discussion, on any topic, the orientation frequently reveals a pattern, such as A, B, A, B, C, A, B. The group will cycle around returning to these places, as if they were landmarks on a map or squares on a board game. As you start to hear this, begin to cluster similar ideas together. The act of extracting these landmark locations of ideas will help the group focus. They may go deeper into exploring one perspective, which they can choose by seeing all the options more clearly. The options start to get separat-

ed from the individuals who expressed them. In time, looking at the chart, someone begins the synthesis process—creating bridges between these landmarks. This shifts members of the group off their individual positions and into developing new alternatives. More on that in a minute.

Another pattern I hear frequently is one that happens when crafting a mission statement. Some folks want everything spelled out—who is the customer, the shareholder, and how are they benefiting (A)? Others want a timeless and global statement without specifics—any specific seems that it might potentially limit the future (B). As people struggle with the angst of not only the right words but this philosophical dilemma of how to structure the statement, other individuals decide to nit-pick about spelling or analyze the meaning of a particular word (C). At this point, someone usually jumps in, questions and wants to change the name of the organization (D).

The field is now open to considering whether to change the product or service the company is providing. Sometimes it becomes clear that people don't know what product or service they are providing and to whom. Again, the pattern may be A, B, A, B, C, D, and spiraling. In this situation, I think what I hear is more about human nature than about the individuals—this is our struggle with definition and closure. It also expresses that individual perceptions become anchor points along a continuum, but often only the point is seen and the connecting continuum remains hidden.

Listening for Interpersonal Dynamics

There may be interpersonal dynamic patterns—who dominates, who does not feel heard, who goes off on tangents, who repeats the same point, who is impatient, who holds the power, and what the history of a group or team is. What you do with this information depends a lot on your role with the group,

history, and the level of trust that has been established. For now, listening will give you a lot of clues. You may want to do some investigating on the sidelines to find out what are the historical, political, personal, and organizational roots of what you are hearing.

Listening for Synthesis and Connections

People have different ways of expressing themselves and frequently get immersed in and attached to their own ideas. Of course, you and I have never done that, right?! Because participants are immersed in detail and frequently attached to their points of view, they may not hear the connections between their ideas. You, however, will hear similarities of intent, design, and bridges between thought patterns. This is where not having a content expertise is to your benefit—you can hear what is going on in the "big picture." This ability to form connections grows as you start listening for intention behind an idea.

For example, I was in a meeting with a group of engineers, designing a new piece of equipment. I had no idea about the intricacies of their technology and didn't need to. There were enough experts in the room. What I did hear was that each design had certain common elements and we set about creating models where those commonalities could be the starting place of an integrated design.

During discussion, participants' viewpoints are expressed, honored, and captured on one big chart. Those points of view, once staked in the ground, now form part of a landscape. In this open and wide landscape, paradoxes inevitably arise. Don't let this bother you—by allowing contradictory statements to remain you may arrive at a higher synthesis.

In the act of contributing, the participants let go of their ideas. Their attention can now be on looking for new connections. Contradictory elements can shift and form new relationships to each other. Opposites mutate into new options. As this begins to happen, there's a tangible shift in the room. When participants start referring to symbols and images instead of the word expression of their ideas, you know you are heading toward synthesis. "There's something missing between the blue box and the green cloud" or "Draw an arrow between the orange comments and the purple circle" signals that you have moved into pattern seeking. Yippee! You're going somewhere called integration!

Listening for Conflict

So often, the person who doesn't feel heard will filibuster and stay on their point, repeating it despite what the group is doing. This same person may leave the room, be distracted, read unrelated papers, have side conversations, and in general, not participate. These are all signs of nonengagement and may be specific to the individual or may be expressing something that is true for more members of the group.

Frequently, the conflict between people has more to do with the way they express themselves than with the content of the topic. Conflict in personal style, historical baggage and resentments, fear and mistrust may all be factors that are embedded within a content conflict. A lot of this may not be conscious.

You can respond to what you are hearing by drawing jagged lines around a "hot spot" or faces with expressions of stress or fear to depict what is going on energetically. In doing this, you help the group acknowledge the issues flowing beneath the surface.

In one meeting, where employees were feeling unacknowledged and stressed from overwork, I drew stacks and stacks of paper and stressed-out characters near the stacks. The employees felt heard and could point to the chart and give more details to help their managers understand the situation. It was the beginning of a change.

EXERCISE:

Listen for patterns of processing, interpersonal dynamics, synthesis, connecting, and conflict. Create situations where you are observing meetings without having to be a participant, recorder, or facilitator. Give yourself the luxury of observing. Practice listening on these different channels and take notes about this. You need to pull back your focus, off specific words and content, to hear the landmark positions and interpersonal dynamics. When you practice listening without having to record or facilitate, you carve out space in yourself. You prepare the ground within yourself so that you are more open to receive and listen on these channels. Then, when you are in a recorder or facilitator role, you'll be able to shift more easily between channels.

Some of this practice involves volume. Go to a lot of meetings. No matter what the topic, meetings are all human beings discussing something. The patterns repeat themselves across industries, run through profit or non-profit businesses. Not just business meetings—go to clubs, associations, groups, gatherings of families and friends, and listen at these levels. While content varies, listen for ever-present patterns. It's quite fascinating and once you get started, it's hard to stop!

Banishing the Critic, Part Three

Making room in the psyche to draw means making room to be free from the past. This can take many forms in your personal mythology. These exercises are good to do with some time, quiet space to reflect, and lots of paper and markers handy to record your inner journey.

EXERCISE:

Contact your past self. Take a mental journey to your childhood and start to answer these questions. You may want to close your eyes and imagine yourself back in time when you were much younger.

- What did your teacher say about what you created?

- Who did you compare yourself with?

- Who did you envy?

- Who among family and friends was talented and artistic? What were your ideas about talent? Did you think you were talented?

- What did your family say about what you created?

As you come back to the present, open your eyes and make a drawing or write about what you experienced. If it's full of messages that you no longer want, you can burn the paper. If there were people and messages that were supportive, be sure to capture those too. In the light of what you currently know about your blossoming ability to draw and capture ideas, can you see how old negative messages are no longer useful or relevant?

In case you have trouble letting any of these recycled tapes go, you probably want to look at what is gained by keeping them. For example, if you really can't draw, you don't have to risk, you don't have to hear or believe that people appreciate what you do, you don't have to publicly embarrass yourself, you can hold on to a "poor me" self-image. What are your hidden benefits?

Now, these are two whopping lists of messages, all the old tapes, and all the hidden benefits. Wow! If you fed these to a dog, it would roll over and howl with a stomachache. And you wonder why you were having a hard time doing graphics live!

There isn't a lot of "doing" going on here—instead, you'll be witnessing and shining a light into the darkness of these old mind tapes. Shining the light of your awareness on this territory is the work! The messages are so absurd, yet the ruts so well worn, that you may find yourself traveling these self-doubting or self-critical paths a ways before you notice. When you do notice, dust yourself off, take a look at how you got there, and pick up your markers. Buddha is quoted as saying, "It's not how long you have forgotten, but how soon you remember."

Now, try being here now, past the field of projections. Now that you have got lurking shadows out of the way, let's look at the present. Sometimes it's possible to project our own criticism into the comments, gestures, or expressions of another person. Well, maybe more than sometimes.

When working in groups, it's helpful to notice who you have judgments about—unless you don't have any and are already a saint. A person may remind you of someone in your life who is or was unsupportive or has an opposite style of personality, processing, or communicating. It's likely you'll think they're judging you. It works like a magnet: you remind them of someone who was unsupportive or who they felt threatened by too. An individual may feel threatened by you because they think they can't draw, don't see themselves as creative, so they feel resentful. It's like a time warp, a mutual knot that you have a chance to untangle now.

Projections are just that—they aren't about you—and your projections aren't about the other person. If this is something that's coming up for you, get curious and go exploring. Ask yourself: Who does this person remind me of? What's triggering me: how they look at me, something they said, their silence, their body language? Your action may be to do some inner work on clearing out the past. Or how about finding out what's real through questioning and conversation? It's so much more interesting to get a reality check!

EXERCISE

Think back to the last meeting or training you were in where you experienced concern or insecurity about how someone saw you and your work. What was the person doing when you had that feeling? What triggered you: a look, something said, the silence, body language? If the person spoke to you, what were the exact words? How did they make you feel? Examine the feeling and get curious. Be specific: where do you feel insecure in your body? How does it look, how big is it, what words are associated with the feeling? If it's familiar, go rooting around for what memories

it's linked to. Are you reacting to the current words and behaviors or to your internalized historical arsenal? Do this investigation with anything else that the person did or you imagined the person was doing.

Banish the Critic

This clearing has a cumulative effect. It gets easier and easier to separate history from present circumstances. Partly, you are getting familiar with your personal set of triggers, so you can recognize them as they arrive. Before, you got merged and smushed, believing the content of your inner critic. Partly, you are healing the past through exposing the messages and tapes that you've been hauling around. It gets easier. The critical attacks are more obvious, increasingly transparent because you've gotten skilled at recognizing them.

Contact Your Inner Muse

Any time you are involved in a creative project, which graphic facilitation is, you'll want to connect with a part of yourself we can call the inner muse. Artists and poets talk about being seized by an inner muse when they are in a creative fervor. Each of us has an inner muse who is the guardian of our creativity and has information, guidance, and insight for us.

Are you doubting that you have a muse? Haven't heard from her in a while? Muses are sensitive creatures who come forth when honored and retreat when not appreciated. If you have not been in contact with your muse, she may need some coaxing and encouragement to rekindle the relationship. But reconnecting with your muse is entirely possible—yes, for you too! Take some time now to meet and develop a relationship with your muse, the part of you that already knows how to do graphic facilitation.

The messages from the muse can be subtle or blaring, a directive inner voice saying, "Capture this BIG," a flash of seeing a border of puzzle shapes, a magnetic pull to go to one side of the chart. As an example, one afternoon last summer, I was sitting in the back of the room during a presentation at a

board retreat. For no particular reason, unrelated to what was being said, I began sketching a bottle of soap bubbles with bubbles emerging and overflowing. I'd never drawn it before. Fifteen minutes later, when I was up at the front of the room, capturing the discussion with graphics, the speaker used a metaphor of soap bubbles! My muse must have been giving me advance warning so I had time to practice this sketch.

Maybe I'm imagining, dreaming, or fantasizing. But who's doing it? I am—and you can too! Some part of you already knows how to draw, how to work with groups, how to deal with big blank pages. In spite of your doubts, when you pretend that your muse knows the answers, you'll be surprised by what comes out of you.

EXERCISE:

Find a comfortable place where you can sit relaxed and won't be interrupted. Have paper and markers nearby so when you open your eyes, you can draw what you sense. Close your eyes. Tune into your breathing and let the gentle rise and fall of the breath take you deeper and deeper into relaxation. Go to a comfortable and beautiful place in nature, a place where you feel very, very good. This may be a place you like to go in real life or one you visit in your imagination. Sitting or lying in this place, notice the temperature, the landscape, how good it feels to be here. Ask to meet your inner muse and be ready to greet her. Because muses are the essence of creativity, they may show up in any form: a butterfly, hummingbird, a person, an elf.

As you meet with your muse, ask her to help you use the graphic language with comfort, ease, and confidence. In this special place, you may want to have a minigraphics session with your muse. Ask her how she will communicate with you when you are in meetings and trainings using

graphics. Will it be through an inner visual flash of what to draw, a message you hear with your inner ear, a sensation that pulls you to an area of the chart? Will it be linked with an outer sight, sound, or sensation?

Take as much time as you need with your muse. Establish a way that you can consult her and communicate with her when you are in meetings or trainings. For example, anchor the connection with something that you can do in real time, such as picking up the markers, touching the paper, or taking a sip of water.

As you get ready to come back, see if she has anything else to say to you. If you have any questions or want to make any agreements about how to communicate or when to meet, do that now. As you say good-bye, know that you can contact her whenever you want to, whenever you need to.

When you come back to the present, capture your experiences in a drawing. Allow yourself to revisit the drawing and your inner muse frequently. This will add another dimension to your experience of graphic facilitation. Let your inner muse show you the way....

Building a Lexicon:
Create Your Own Image Dictionary

Every industry has its own language, concepts, and acronyms. Think back to the last several meetings you've gone to and create your own list of key concepts that came up frequently. Jump forward to a training or meeting you are going to soon. What are the key ideas you expect to be discussing? Do you have ways to quickly sketch the essence of these ideas?

Some of the icons we've practiced already may be applicable—others need to be invented. Remember, keep the graphics, without too much detail—you only need to suggest the idea. For concepts you use frequently, you'll want to brainstorm several images so you can add variety and have options.

You can build your lexicon from words or graphics. From either direction, this means you can always expand your graphic vocabulary. A lively brainstorming session with a group or team is more fun than working solo and quickly generates new options.

EXERCISE:

BUILDING FROM WORDS

Work alone or in a group, with a large sheet of paper and lots of colored markers. Create a cluster of ideas in words that are elements of the concept you're working with. For example, IDEA is a flash, thought, innovation, surprise, experiment, flash out of the blue, out-of-the-box thinking, breakthrough. There are many ways to illustrate each of these concepts. Make sure you come up with at least one graphic for each concept.

Next, look for images that are interchangeable to increase your repertoire. In most cases, interrelated words can be depicted by many of the same graphics—so you will find a high degree of overlap and interchangeability. The good news is you've got multiple options for depicting a concept. If it's an idea you use frequently, it's more fun to have several alternatives for how to express it.

BUILDING FROM THE GRAPHICS

Now, start with one graphic image and brainstorm all the ideas that could be depicted with this single image. Create more illustrations as alternatives to capture the essence of each associated idea. Again, look for interchangeability, seeing how many images could be swapped back and forth between concepts.

For example, an arrow going into a target could be used for focus, goals, direction, on target, bull's eye, results, success, aim. Focus could also be illustrated with eyes, a telescope, or glasses. A telescope could represent

IDEA

aim, direction, or target. As you can see, each of these related concepts can be illustrated in a number of ways. Cross-pollinate and see how many of the images are interchangeable and would work in numerous places. Once again, you have effectively expanded your toolkit of images!

These brainstorming sessions are fun to do with other people. Call in help, especially if you are stumped or in a labyrinth of thinking no images exist for your idea, your concept is too technical, too complex or whatever flavor of doubt you are swamped in. It is refreshing and liberating to see what other people come up with even while you're blocked. Essentially, you're creating a graphic thesaurus. Keep a verbal thesaurus nearby to trigger fresh ideas.

BUILD YOUR LEXICON

On one chart, sheets of note paper, or note cards, draw images for the words you use most frequently. If you want to, draw the step-by-step path to create the image. Be sure to include the ones you've just created. Before your next meeting or training, look these over and practice those you want a refresher on.

EXPAND YOUR GRAPHIC VOCABULARY

Let's take a look at some more involved concepts. Keep in mind, you already could illustrate these concepts with symbols, colors, or the word written with expressive lettering. But why not have more choices?

Some of these images build on earlier ones, such as the running people for a team. If so, part of your personal strategy is to practice the running people while doodling, on your own time, without any pressure of performing in public. While you're getting comfortable with the running figure, use simpler images such as circles, half people, or arrows to depict team.

Next, look for how to build the shape of the running people and other complex images in stages so that each stage would be usable if you had to leave the graphic at that point. Look for the lines that yield something recognizable and draw these first. A useful order, in this case, is the arrow, the head and shoulders, arms and upper body, and finally, the legs and feet. At each juncture, you've created a perfectly respectable and recognizable icon for team. Because you may or may not have time to return to the graphic, the order you use to draw an image makes a big difference. When you are working live with a group, be willing to abandon a graphic to capture new words.

EXERCISE:

Get in the habit of free-associating to get at new ways to represent more complex or abstract images. A lot of the actual drawings will come into play and you'll also create some new drawings. Here is a starter kit to get you rolling. Let's illustrate these concepts: respect, freedom, future, downsizing, trust, community, no judging. Here's an example of associating to help you search for more images.

DOWNSIZING

More to less, funnel, inverted triangle, lots of people to fewer people, selection, circle of who stays and arrow for who goes, sadness, out of control, slashing, lightning, do more with less, a shrinking mountain, a bar graph with people going down, an arrow spiraling, large circle, triangle, or square going to a smaller circle, triangle, or square.

FUTURE

Unknown, uncertain, sunny, rosy, potential, vision, mountains, rising sun, hope, diamond, newspaper, futuristic stuff like biotechnology, robots, the Internet, technology.

Okay, now you get to make word associations for trust, respect, community, and no judging. No rules, no time limit, no wrong answers…. Go for it!

Do the same free association with any other concept you want to illustrate. Remember, if you get stumped or just want to have more fun, ask for help!

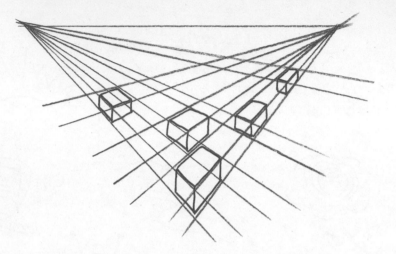

Perspective

Remember our diamond? The reason why the diamond "works" is that it's indicating two angles of perspective. Draw a horizontal line and then extend the sides of the diamond out to the horizon—this gives you a framework for drawing things receding into the distance. You can see this by looking at drawings of boxes, buildings, the treasure chest. This can be very mentally challenging to stretch and shift your inner mental model. We've gone into a new zone now, out beyond flat!

Look at how the Vs intersect to create a stretched X. This creates more angles to build shapes of. This is very useful for adding flaps to the box to indicate different angles of perspective. You can use these lines to help you create the illusion of perspective. Think of the lines as guides and draw several lines radiating from the points and past where they intersect. Following the guidelines, start drawing in boxes, arrows, and simple shapes. You will see that the objects in front are larger than the objects in back. You can build on this general principle about perspective with groupings of objects through the use of overlapping to make things appear to be in front of others. To overlap, start

with the object that appears to be most in the front. Draw in other, partial objects, only revealing a portion of these. Experiment with some of the basic objects—create arrangements of three money bags, three toolkits, and so on.

You can use this same information and the same principles to create the illusion of perspective with lettering. The key is to be consistent between letters and the surface they are on. If the object follows a certain angle, keep the lettering aligned to the same angle. It will help you to experiment with writing a word in perspective, on a shape that's in perspective. Be patient with yourself. This may take some getting used to—we're still stretching our spatial visualization muscles.

EXERCISE:

Practice drawing the two-point perspective lines and play with different collections of objects: boxes in one drawing, arrows in another, treasure chests in a third. Get used to thinking about how these lines can guide your placement and size to create the illusion of dimension. Eventually, you will visualize the lines internally and this "perspective thing" will fall into place. You'll have a new and different kind of "lined paper" on which to align whatever you choose to draw.

Practice creating groupings of objects: three money bags, three boxes, or three cubes. Draw the largest object first and in front. Fill in the two other objects, smaller and only partially showing to indicate depth. These are great illustrations for the center of a chart.

Practice creating perspective lines with a horizon and then several large Vs. Now draw a box along these lines. Next, add parallel lines within your shape and write a word

inside these lines. The writing will be larger in front than in back and parallel to the shape of the object. The overall effect is that the letters work with the shape to appear to be receding into the distance. Experiment with writing the word first, then drawing the shape around it—all following the same perspective lines. If you have some favorite angle at which you like to draw objects, be sure to practice aligning the writing at that angle.

Your Practice Plan

You've gotten this far and this is a critical juncture. Like any language, graphic language grows with use, care, and PRACTICE! Like any language, it is a garden that needs water and care each day. It may be ten minutes one day and several hours another. If you use it, apply it, and experiment with it, you'll be speaking a graphic language! Your fluency will blossom and grow quickly. The opportunities to practice are abundant, especially because so many of the skills are about focusing your awareness.

Whatever you practice will be what you use. So, while it's tempting to not practice any images that you aren't "good" at, you're ensuring that you won't get good at them. Practice in the privacy of your journal, scheduler, or notepad. Practice small and practice large. Your repetitive motion plants the image into muscle memory so it's there when you want it—up in front of a group of people!

Create your own mindmap of where and how you want to practice. Pull some ideas out from the ones here to fuel your thinking. Add your own mix of what meetings, presentations, and opportunities you can add to these. Now, identify your first several steps with dates—in the next ten days! Post this map in a prominent place on your wall or desk and reward your progress by adding color, stars, symbols, and encouraging comments as you continue

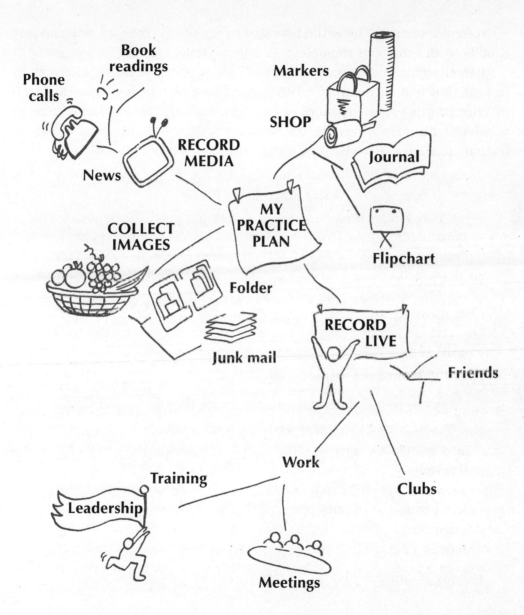

Phone calls

Book readings

Markers

SHOP

Journal

News

RECORD MEDIA

MY PRACTICE PLAN

Flipchart

COLLECT IMAGES

Folder

RECORD LIVE

Junk mail

Friends

Work

Clubs

Training

Leadership

Meetings

on your graphic path. Over time, be sure to revisit this list and your imagination for new ideas for other ways to nurture your graphic language ability.

Keep in mind that you don't have to do everything at once. Start with the images that will be most useful to you. As you use these in meetings, also practice privately, growing more comfortable with the next group of graphics you select. Your initial graphic toolkit may be as few as ten images that you use a lot. Create a step-wise plan if that helps you. Here's a sample:

Week One: Practice airplanes, money bags. Do preprepared charts for next meeting.

Week Two: Do an airplane in the next training (pencil it in advance if needed). Do a list with colors and some graphics. Work on banners. Brainstorm images with the team that we can use at the next training.

Week Three: Do a chart with clustering, using money bags to talk about resource issues. Practice banners in my scheduler. Do a one-on-one session with Dan and work large with a cluster diagram of his issues about expanding his business.

Increasing Visual Awareness

- Copy symbols from magazines, junk mail, packaging, signs, logos
- Get a sketchbook and take a walk in your neighborhood. Look for combinations of pictures and words: traffic signs, store signs, sides of trucks, store windows, people's clothes.
- Collect images from magazines, catalogues, or newspapers. (The left-hand corner of the front page of USA Today has great charts and graphs.)
- Collect images from TV: icons from the news, weather, or cartoons.
- Look at children's books, cartooning books, charts, and graphs.

- Find old and current *New Yorker* magazines and look at the diverse styles of the cartoonists.
- Check out the grocery store for graphics in packaging, use of colors, banners, and use of defined space.
- Notice different colors: when you and others wear them, when you see them, how they are used in advertising and design.

Increasing Listening Awareness

- Listen for visual metaphors in language.
- Listen for where the speaker's passion is.
- Listen for what affects your body and where you are affected.
- Listen for connections, themes, and patterns in things people are saying.
- Listen for conflict.
- Listen for what is not being said.
- Listen beyond the content, for what is happening with the process.

Increasing Sensing and Presence

- Notice your breathing while you are in groups.
- Notice how you are standing.
- Work with your internal checklist before, during, and after a session.
- Notice what emotions are triggered with specific people or content.
- Notice what thoughts pull you off-center (people, space, logistics, etc.).
- Notice how what you are eating and drinking affects you.
- Notice how different clothes, shoes, pens, and materials affect you.

Increasing Ease with Drawing

- Practice, practice, practice. (I'm sorry, but it's true!)
- Select a handful of images that you want to establish as your basic toolkit, based on ease and frequency of use.
- Set up areas at work and at home to work on large charts.
- Get a sketchbook and practice frequently.
- Doodle nonstop.
- Get together with friends and coworkers for drawing sessions.
- Get help with specific images from friends, books, or teachers.
- Alternate working large and small.
- Illustrate your calendar, faxes, and notes.
- Create precharts, handouts, illustrated overheads.
- Take graphic notes at lectures or book readings.
- Increasing ease with working live
- Look for nonwork opportunities to capture ideas: church or temple groups, family, clubs, community groups.
- Work one-on-one with friends or co-workers when designing a project, having a discussion, or mapping out a transition.
- Volunteer to be the graphics person for a meeting.
- Map out a family vacation.
- Map out a family conflict with kids and partner.
- Map out a move, decision, or options.
- Depict a project plan with coworkers.

Ending Is Beginning

You have what you need to create graphics and work live with groups, teams, and individuals. This is a door to walk through—a gate through which lie all the times you'll use this knowledge. It takes courage to deal with all that white space of a blank chart, to deflect any remaining interior critical voices, to manage people's expectations, to allow yourself to be a witness to process without having to be a content expert. It takes presence to trust your ability to witness and mirror. It takes being present to keep your primary focus on honoring the group and not getting caught in ego about creating the drawing.

Where will this take you? What will come up? Who will you work with? It is a mystery where speaking a visual language will lead you—in mapping out your own thoughts and designs; capturing essence in meetings with coworkers, friends, family, nonprofits, or profit organizations. There is no agenda for how you will integrate and apply all this information. Anytime people are gathered to think about issues, projects, or systems is an opportunity for you to practice and offer your graphic witnessing.

As you use these skills, several things will happen. You'll grow increasingly confident and take more risks to express what you are perceiving. People will appreciate how you help clarify their thinking and focus a process. Their feedback, acknowledgment, and appreciation will fuel your continuing development. You'll discover capacities in yourself to listen, be present, select, and depict essence graphically. And you'll make a lot of blunders and learn from each one of them.

You may find yourself in situations that seem over your head in different dimensions. It may be working with large groups, difficult personalities, highly charged situations, or very technical information. When and if this happens, here are a few things to remember:

- It's okay to capture words only.
- It's okay to ask for help.
- Take a deep breath—breathing helps.
- Experiment—you will learn from whatever happens!
- You have the inner resources to embrace what is happening.

You've got a new language to speak, draw, and use to communicate. My prediction is that you'll surprise yourself and probably already have. Breathe into any nervousness that you may be feeling and you'll make an alchemical shift from nervous to excited. So many people will appreciate your courage, creativity, drawing, and listening. This will fuel you to go deeper, practicing more and growing in how you integrate a graphic language into your work and your life.

The essence of this work is courage. The root word is *coeur*—heart, to act from the heart. Love yourself for taking a risk. When you bring an open heart to your listening, you will hear through the heart of compassion. Compassion for struggle, pain, content, and process. Caring for people, witnessing interactions of individuals and groups will transform them as well as you.

By now you know, this is not about the drawing. The drawing is an excuse to jump in and engage, listen, extract, and focus. Into the juicy, alive, bubbling river of interaction. It is a personal, professional, and interactive journey you are embarking on. You will be transformed through the act of doing this work.

With open heart, open mind, and open marker— go for it! Draw out ideas!

· Hands•On Graphics ·

Our goal is to help you utilize graphics as a powerful communication tool. The visual sharing of ideas stimulates creativity and understanding in business. We provide professional training, facilitation and illustration to help you integrate a graphic language into your work and personal development.

TRAINING

A lively two-day session for trainers, presenters, facilitators and anyone who wants to get ideas across. You will learn to communicate ideas quickly with simple and powerful graphics. You will learn to listen for key concepts, translate ideas into pictures, draw spontaneous sketches and organize information into graphic formats. Customized images will add impact to your trainings and presentations. We will share techniques to promote group interaction and make concepts memorable. You will become confident in your ability to sketch ideas quickly and easily. This is a highly experiential session—be ready to move, participate and draw out ideas!

We offer customized sessions including conference presentations, one-day classes and advanced graphic facilitation training. We teach you to communicate using a visual language.

FACILITATION

Make your meetings powerful, effective and memorable. Graphic display of process and discussion stimulates participation, creativity and focus.

Key ideas are captured in a colorful combination of cartoons and words. Large wall charts (4 ft. by 12 ft.) are hand drawn during discussion, promoting "big-picture" thinking and sparking fresh ideas. Spontaneously created charts are touchstones for interaction which propel the group to define goals, clarify differences and form agreements.

Graphic facilitation has been used effectively in brainstorming; visioning; strategic planning sessions; annual retreats; focus groups; project and product planning; and mapping transitions with groups and teams. Reports, charts and posters help anchor ideas and keep concepts alive long after the meeting. We facilitate effective and memorable meetings.

ILLUSTRATION

Illustrated ideas are remembered—bullet points and words are forgotten. Get your ideas and key points across in colorful drawings. We create visuals to support your business communication needs including illustrations for presentations, trainings, printed materials and web sites. Colorful posters, illustrated handouts and overview maps create a cohesive visual message. We offer design consultation to make your communications and presentations come to life. We draw your ideas into creative, colorful visuals.

CLIENTS/PARTIAL LIST

Amgen	Deloitte & Touche	MTV
ABN*AMRO	Ernst & Young	Shell Oil Company
AT&T	First Chicago Bank	Sprint
Becton-Dickinson	Intel	VISA
Continental Airlines	Merck & Co., Inc.	

"Hands•On Graphics' step-by-step process turns even the most hopeless of us into a fledgling Picasso... A great facilitation tool."

—Joan R. Smith, Director
Sales & Marketing Training, Continental Airlines

"The Hands•On Graphics program exposes us to the power of visual communication...I'm hooked!"

—Lisa J. Crawford, Manager
Training & Development, Becton-Dickinson

Call us today at 415-383-0246 or 800-773-DRAW. Visit us on the world wide web at http://www.cyberzones.com/HandsOn. We look forward to drawing out your ideas!

Hands•On Graphics, 20 Sunnyside Avenue, Suite A140, Mill Valley, Ca 94941

· Bibliography ·

Arrien, Angeles. *Signs of Life: The Five Universal Shapes and How to Use Them*. Sonoma, Calif.: Arcus Publishing Company, 1992.

———.*The Four-Fold Way: Walking the Paths of the Warrior, Teacher, Healer, and Visionary*. San Francisco: Harper San Francisco, 1993.

Cameron, Julia with Mark Bryan. *The Artist's Way: A Spiritual Path to Higher Creativity*. Los Angeles: J. P. Tarcher, 1992.

Edwards, Betty. *Drawing on the Right Side of the Brain*, rev. ed. Los Angeles: J. P. Tarcher, 1989.

Hanks, Kurt and Larry Belliston. *Rapid Viz: A New Method for the Rapid Visualization of Ideas*. Menlo Park, Calif.: Crisp Publications, Inc., 1990.

Holmes, Nigel. *Designer's Guide to Creating Charts & Diagrams*. New York: Watson-Guptill Publications, 1991.

——— with Rose DeNeve. *Designing Pictorial Symbols*. New York: Watson-Guptil Publications, 1990.

Hurd, Thacher and John Cassidy. *Watercolor for the Artistically Undiscovered*. Palo Alto, Calif.: Klutz Press, 1992.

Keener, Polly. *Cartooning*. Englewood Cliffs, N.J.: Prentice Hall, Inc., 1992.

Kistler, Mark. *Mark Kistler's Draw Squad*. New York: Simon & Schuster, 1988.

Koren, Leonard and R. Wippo Meckler. *Graphic Design Cookbook: Mix and Match Recipes for Faster, Better Layouts*. San Francisco: Chronicle Books, 1989.

Macaulay, David. *Great Moments in Architecture*. Boston: Houghton Mifflin Company, 1978.

———. *The Way Things Work*. Boston: Houghton Mifflin Company, 1988.

Maddocks, Peter. *How to Draw Cartoons*. London: Guild Publishing, 1991.

Metzger, Phil. *Perspective Without Pain*. Cincinnati: North Light Books, 1992.

Morgan, Gareth. *Images of Organization*. Thousand Oaks, Calif.: Sage Publications, Inc., 1986.

Nachmanovitch, Stephen. *Free Play: The Power of Improvisation in Life and the Arts*. Los Angeles: J. P. Tarcher, 1991.

Schwenk, Theodor. *Sensitive Chaos: The Creation of Flowing Forms in Water and Air*. Hudson, N.Y.: Anthroposophic Press, Inc., 1990.

Sibbet, David. *I See What You Mean: An Introduction to Graphic Language Recording and Facilitation*. San Francisco: Grove Consultants International, 1981.

Tollison, Hal. *Cartooning*. Laguna Hills, Calif.: Walter Foster Publishing, 1989.

Tufte, Edward. *Envisioning Information*. Cheshire, Conneticut: Graphics Press, 1990.

White, Jan V. *Graphic Idea Notebook*. Rockport, Mass.: Rockport Publishers, Inc., 1990.

Wurman, Richard S. *Information Anxiety: What to Do When Information Doesn't Tell You What You Need to Know*. New York, New York: Bantam, 1990.

· Index ·

P

Personalizing, 119–20
Perspective, 82–85, 142–44
Pink, associations with, 37, 39
Posters, 55–57
Presence
 breathing and, 7–9
 increasing, 147
 sustaining yourself, 123–25
 taking care of yourself, 89–92
Process. See Groups
Purple, associations with, 32, 39

R

Red, associations with, 35

S

Scribbling, 12–13
Scrolls, drawing, 100

Self-criticism, 12–13, 95–97, 131–34
Shading, 30, 52
Shapes, 17–30
 drawing basic, 18–20
 shading, 30
 symbolic meanings of, 21–29
 using, 20
Space, using, 122–23
Speech patterns, 9–10
Spirals, 16, 29
Squares, 18, 23
Stars, 19–20, 26
Strategic visioning sessions, 112–13

T

Telephones, drawing, 49
Thought bubbles, 68

Timelines, 112
Triangles, 18, 22
Trust, establishing, 38

V

Visual awareness, 146–47
Visual language skills map, 3
Visual thinkers, 74–75

W

Wall space, using, 122
Words
 lettering, 40–46, 143
 using others', 11

Y

Yellow, associations with, 36